A TASTE OF CORK

A GOURMAND'S TOUR OF ITS FOOD AND LANDSCAPE

SEÁN MONAGHAN AND ANDREW GLEASURE

FOREWORD BY DARINA ALLEN

The History Press Ireland

First published 2011

The History Press Ireland
119 Lower Baggot Street
Dublin 2
Ireland
www.thehistorypress.ie

© Seán Monaghan & Andrew Gleasure, 2011

The right of Seán Monaghan & Andrew Gleasure to be identified
as the Authors
of this work has been asserted in accordance with the
Copyrights, Designs and Patents Act 1988.

British Library Cataloguing in Publication Data.
A catalogue record for this book is available from the British
Library.

ISBN 978 1 84588 714 8

Typesetting and origination by The History Press

CONTENTS

FOREWORD

A Taste of Cork is the book I've been waiting for – I too share the love, landscape and food. Cork, my adopted county, is thrice blessed with rich fertile soil, an abundance of artisans and supportive locals who appreciate quality. Cork has a long history of food production and was home to the largest butter market in the work in the 1860s. Its fame continues to spread; food and travel writers and visitors from around the world make their way to all four corners of the county in search of artisan foods – farmhouse cheese, smoked fish, cured meats, traditional breads and home baking, local honey and preserves, each with the unique taste of the land from which they spring forth and the personality of the producer so beautifully captured in photographs.

Food and landscape are inseparable and all good food comes from the good earth.

Darina Allen
Ballymaloe Cookery School

ACKNOWLEDGEMENTS

From Seán

This book is dedicated to my two children, Oisin and Sadhbh, with all my love. My hope is that one day you will see all the places described in this book with your own eyes and experience the beauty of Cork as I have, although beautiful places experienced or yet to be experienced will never compare to the wonderful time we had in Cork. My thanks also go to all the food producers who so graciously gave of their time to pose for me. Thank you to my brothers Aidan and Niall; Aidan is a constant source of photographic inspiration and my current favourite photographer and Niall is quite simply the best salesman in Ireland, without whom none of our photographic projects would ever leave the living room into the real world. Thanks also to my mum and dad who are supportive of every venture we undertake and for showing such a keen interest. A grateful mention also to my sisters Sinead and Clodagh. Finally, a big thank you to Cork and the people of Cork for letting me stay in this land of milk and honey. I was told a long time ago that Cork people believe Cork to be the real capital of Ireland; they might be right, but without doubt it certainly is the good food capital of Ireland.

From Andrew

This book is dedicated to my family and to the people of Cork, in particular to those who I have known and met over ten years of living in the country. Cork people are famous for being extremely welcoming to outsiders and I want to thank everybody who has helped to make Cork my home. It has also been a pleasant surprise for me to discover my maternal Cork ancestry at Castle Barrett during the writing of this book and to explore the ruins of Castle Barret with my mother on a beautiful May weekend in 2011.

INTRODUCTION

We are the children of our landscape; it dictates behaviour and even thought in the measure to which we are responsive to it.

Lawrence Durrell

We live in a wonderful country at the edge of Europe that is still wild and beautiful. This book aims to capture the beauty of the landscape in one of Ireland's biggest and wonderfully rich and diverse counties. This is not a guidebook but more a journey through Cork as seen through my eyes, which are visitor's eyes. It combines two of my own personal passions: stunning landscapes and food.

In this book, inspired by the Lawrence Durrell quote above, I aim to portray Cork's majestic landscape and also the produce of the land that feeds us, the children of the land.

Many of the artisanal food producers have been championed by celebrity chefs such as Rick Stein and Richard Corrigan and this book not only shines the spotlight on some of Ireland's finest food producers, it also sets the food in the context of the beautiful landscape in which it is produced. Lovers of Frank Hederman's famous smoked salmon or highly acclaimed Durrus and Ardsallagh cheeses can really see where this fantastic product comes from.

The omission of some more famous landmarks is deliberate as I want to emphasise the depth and breadth of the beauty of Cork and to highlight some lesser-known gems. The book contains my motivation and process behind the photographs as well as some interesting stories about the locations of the photography thanks in the main to Andrew Gleasure who has helped me explore Cork over the last ten years and has never been short of an anecdote on a particular area we have visited. It juxtaposes the landscape with artisanal food producer where appropriate. I hope that this book will encourage you the reader to go out and explore the Cork landscape, smell the country air and taste the fine food that is produced here.

In my opinion the food produced by artisanal producers in Cork is simply second to none and we are very privileged in Cork to have such high quality producers.

I unashamedly admit that this book is principally a photographic book, with its aim to showcase Cork using contemporary equipment and techniques and good old-fashioned patience. To capture the landscape at its best requires returning to an area many times and often at dawn or dusk to find the perfect and often unusual lighting conditions. The sky is filled with oranges and lilacs and deep blues at these hours and to my mind watching a sunrise is one of the most uplifting and privileged experiences we humans can witness. My early approach can prove costly, as getting the images for this book have cost me a set of car keys (jumping eagerly over a cliff-side at dawn) and my car, 'Tilly'. The latter I crashed into a ditch as I turned directly into the rising sun down a back road in East Cork, on my way to capture a sunrise at Ballycotton – I had arrived too late the sun was up and it completely blinded me. I emerged unscathed but poor Tilly's adventures were over.

A fine art sculpture in Inishshannon.

But O, photography! as no art is, Faithful and disappointing! That records dull days as dull, and hold-it smiles as frauds.

Philip Larkin

And so to photography and my working method. Most of us are used to images of Ireland with green fields and blue skies taken in the middle of the day. I've steered away from blue sky images as much as possible in order to give a seldom-seen slant to the landscape in question, but for some scenes the blue skies are absolutely necessary. As for getting up at dawn, the truth is when on holiday how many of us get up before we've had our breakfast? Therefore the majority of us miss the time of day when the land is at its best, sunrise. I often find the rain stops and the land becomes silent just before the sun bathes the land in its golden glow. This is also a reason to present the landscape in this fashion. To produce the images I do takes a lot of planning and pre-visualisation, such as where the sun will be and in the case of my best images, many returns to the same place at different times of the year. I hope you enjoy the book as much as I've enjoyed creating it.

Sean Monaghan, 2011

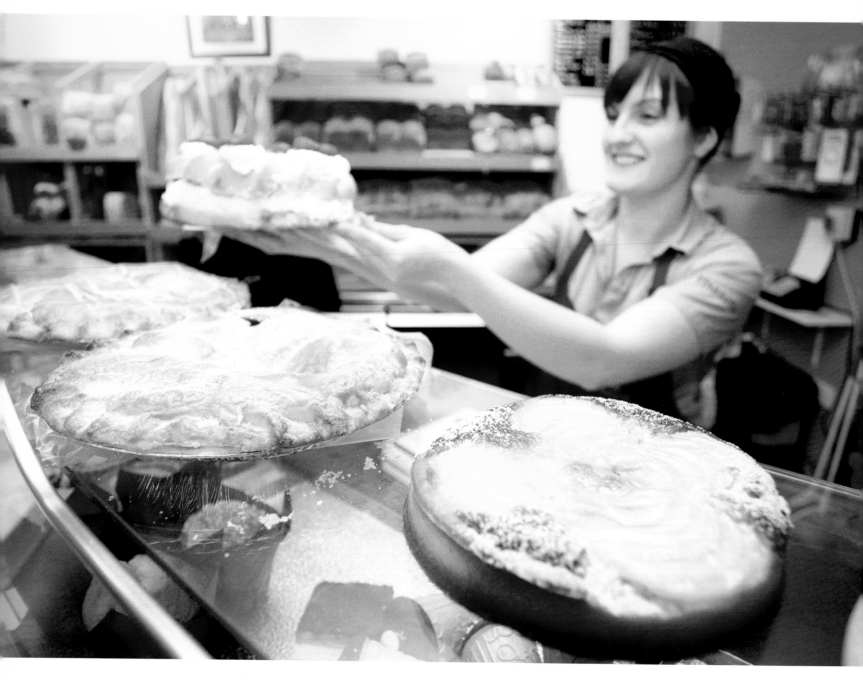

Hassett's artisanal bakery in Carrigaline, without a doubt producers of the best sandwiches in Ireland.

WEST CORK

West Cork today, as any tourism brochure will tell you, starts at Carrigaline, leading down to the Old Head of Kinsale and Inishshannon and sweeps west past Clonakilty and Courtmacsherry Bays. Further west again, the coast breaks into many delightful bays and headlands. Rounding the headland at Baltimore, Roaringwater Bay unfolds with its multitude of small islands. Three narrow peninsulas jut out into the Atlantic and are divided by the waters of Dunmanus Bay and Bantry Bay. The two southerly peninsulas, with their wild and rocky coasts, end at the lonely outposts of Mizen Head and Sheeps Head. Wilder than these, the more northerly Beara Peninsula faces the Kenmare estuary and contains the imposing backbone of the Caha Mountains. In spite of the apparent remoteness of West Cork, this part of Ireland has long been well connected with the rest of the world. British, French and Spanish traders have come and gone for thousands of years. Fleets from Spain and France, Algerian pirates and German U-boats have all raided this area in the past.

Today West Cork has proved to be a Mecca for traditional food artisans, where many of the traditional cheese and other culinary customs have been retained into the modern era. Indeed many people have moved here from Europe and North America for the more tranquil lifestyle.

Ó Conaill's, chocolatiers of Carrigaline.

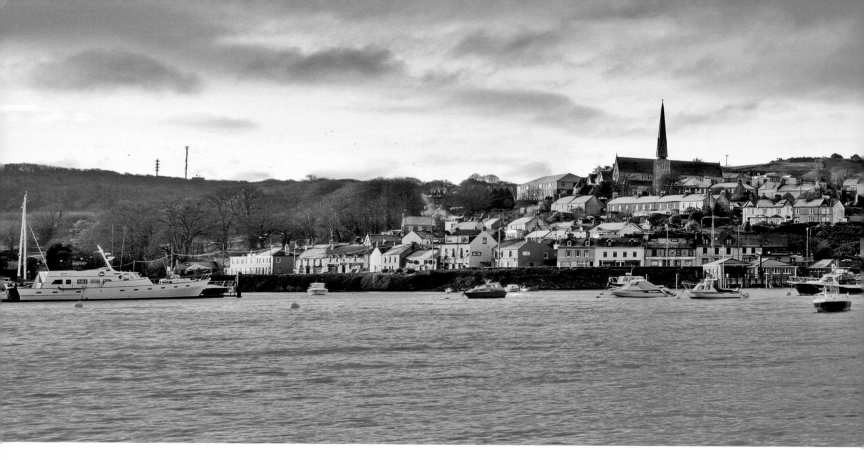

Crosshaven

Beautifully situated on the estuary of the Owenabue River in Cork Harbour, Crosshaven is a popular yachting and seaside resort. The village is famous for the Royal Cork Yacht Club, which has had its headquarters in the village since 1966. The club was established in 1720 and holds the title of the oldest yacht club in the world. Crosshaven hosts the biannual regatta of Cork Week, which is one of the world's most famous regattas and draws huge crowds of competitors and spectators from all over the globe. This shot is a panoramic of Crosshaven taken on a winter's day as the sun rises in the east, side lighting the scene. Soon after taking this shot, snow began to fall and, as the work was done, it was off for some breakfast at Hassett's in Carrigaline and a hot chocolate made from Ó'Connail's chocolate, also based in Carrigaline.

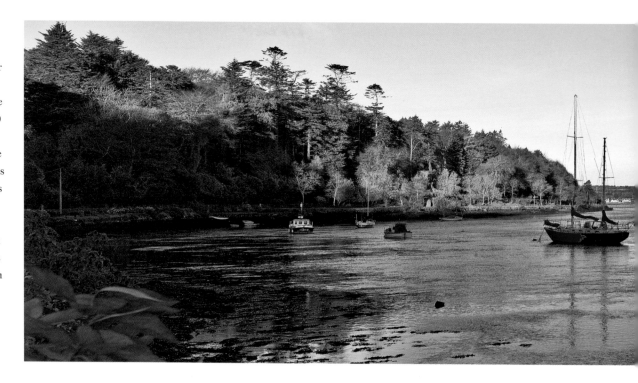

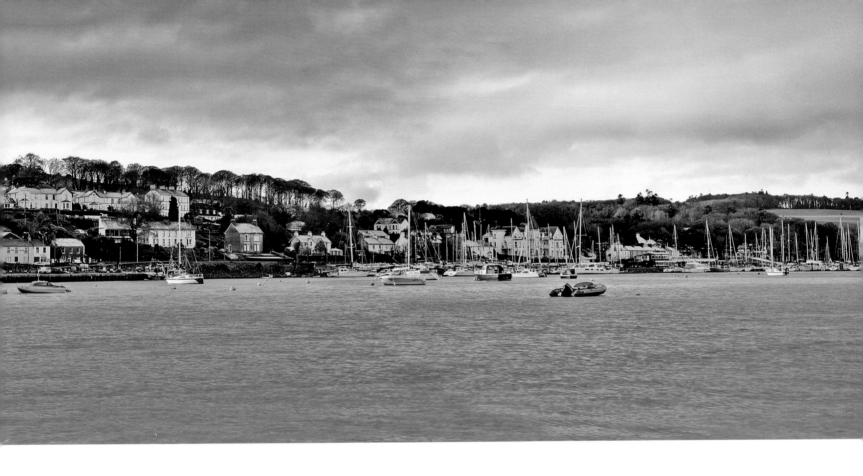

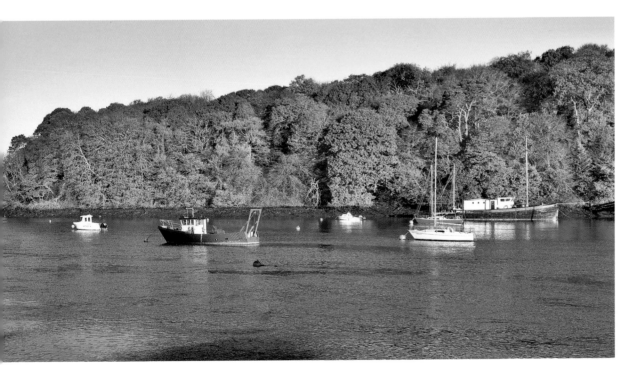

Drake's Pool

Crosshaven overlooks a reach of the estuary known as Drake's Pool. The name reveals a link to Sir Francis Drake, who successfully hid here from a pursuing Spanish force who had chased him into Cork Harbour in 1587. Drake's Pool is now a popular spot for contemporary yachts and boats.

Carrigaline Farmhouse Cheese

The multi-award-winning Carrigaline farmhouse cheese has been handmade by Anne and Pat O'Farrell on their farm at 'The Rock' just outside Carrigaline since 1984. The cheese, made from pasteurised Friesian cows, is available in three flavours – natural, beech–smoked and garlic and herb – and are free from artificial additives and preservatives.

The cheese wheel products (which have been dipped in food-grade wax six times) are very pretty and almost too good-looking to eat.

Carrigaline is derived from the Irish *Carraig-Ui-Leighin*, meaning 'Rock of the Lynes'. The Lynes were a local clan who built the castle in 1170. It is under the shadow of this old castle that Anne and Pat make their fabulous cheese.

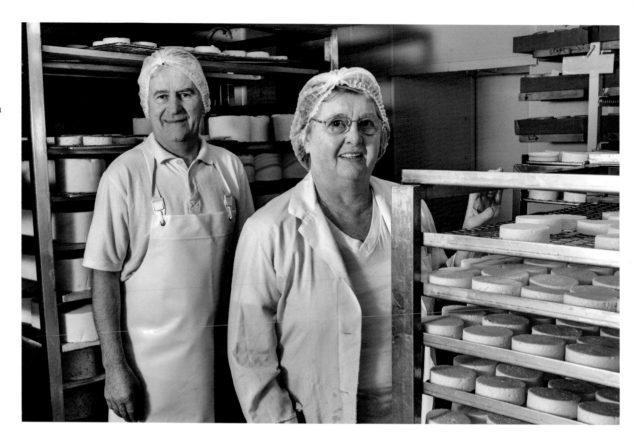

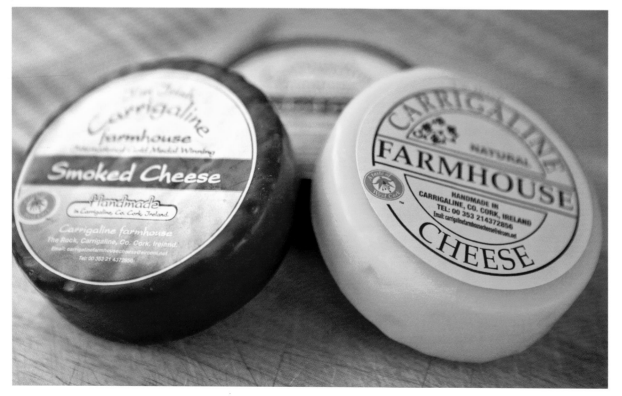

Charles Fort

In Summercove, 2km east of Kinsale, stand the huge ruins of the seventeenth-century Charles Fort. It is one of the best-preserved forts in Europe. It was built in the 1670s and named after Charles II although most of the ruins in the fort date from the eighteen and nineteenth centuries. It remained in use until 1921, when much of the fort was destroyed as Crown forces withdrew following the Anglo-Irish Treaty. Although Charles Fort protected the town from sea attacks, William of Orange attacked from the landward side after the Battle of the Boyne in 1690.

Nohoval Cove

Nohoval Cove is a hidden gem. It's very easy to imagine it as a smuggler's dream location.

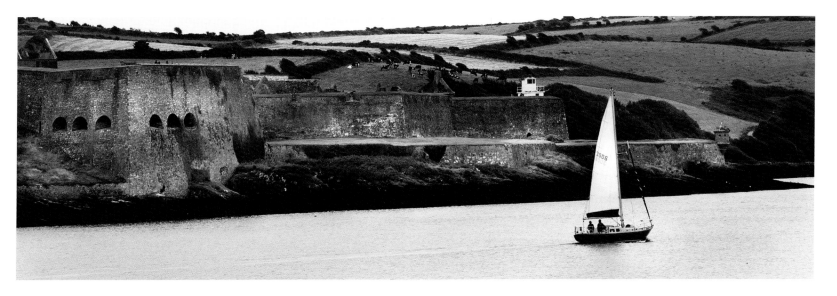

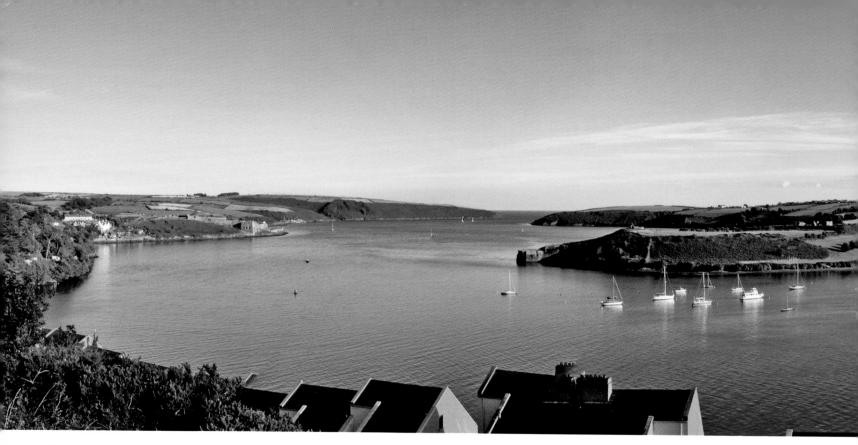

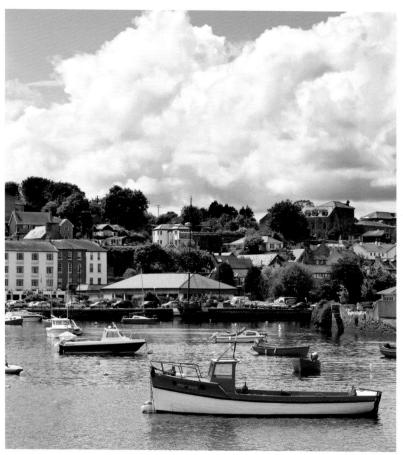

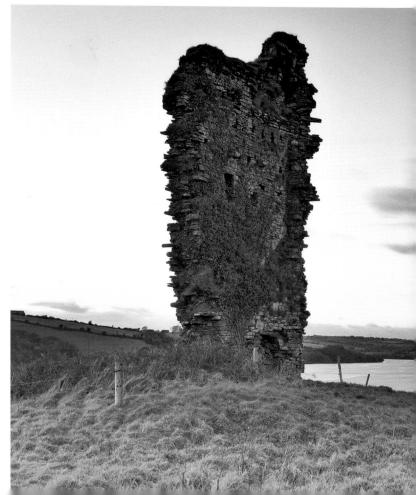

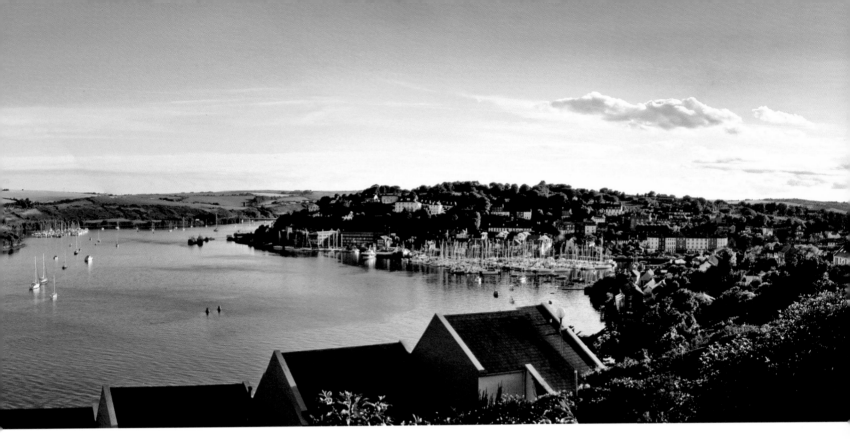

Kinsale

Kinsale is a quaint and picturesque town on the estuary of the Bandon River. Its narrow streets follow the windings of the shore, and the town has a strong Georgian flavour. Beautiful views of Kinsale and the ruined forts on the river can be had from the hills on the Scilly peninsula. The summer crowds that flock here are drawn not just by the scenery and historic buildings, but by the fact that Kinsale is the gourmet capital of Ireland.

The town has played an important part in Irish history. In September 1601, a Spanish fleet anchored at Kinsale and was besieged by the English. An Irish army marched the length of the country to attack the English, but were defeated in the battle outside Kinsale on Christmas Eve. Historians now cite 1601 as the beginning of the end of Gaelic Ireland. After 1601 the town developed as a ship-building port. In the early eighteenth century, Alexander Selkirk left Kinsale Harbour on a voyage that left him stranded on a Pacific island, providing Daniel Defoe with the idea for *Robinson Crusoe*. Today Kinsale is home to many fine restaurents, indeed there is the 'Kinsale Good Food Circle' collection of the best establishments in the town, most notably Martin Shanahan's Fishy Fishy Café. For foodie festival goers, each October Kinsale is home to Ireland's oldest food festival, the Kinsale Gourmet Festival.

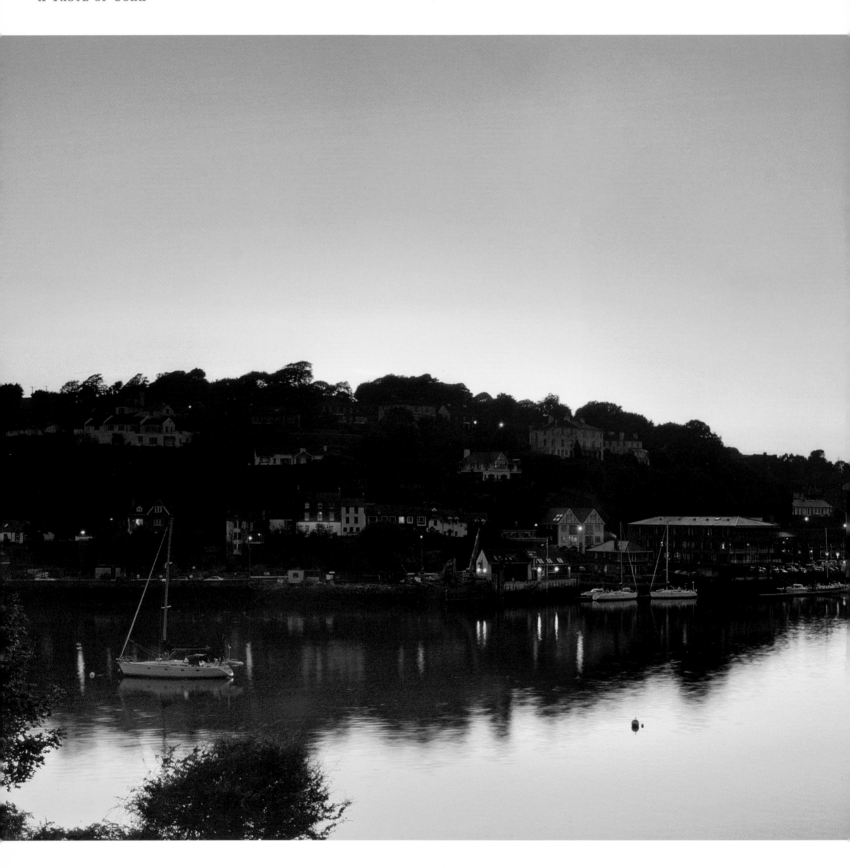

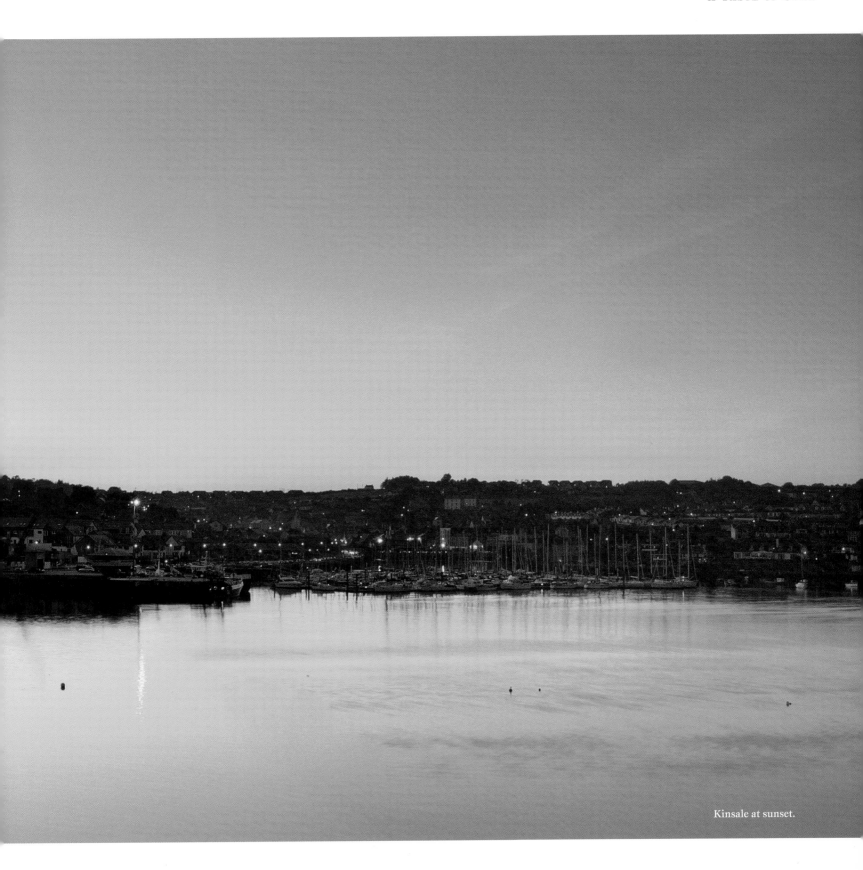

Kinsale at sunset.

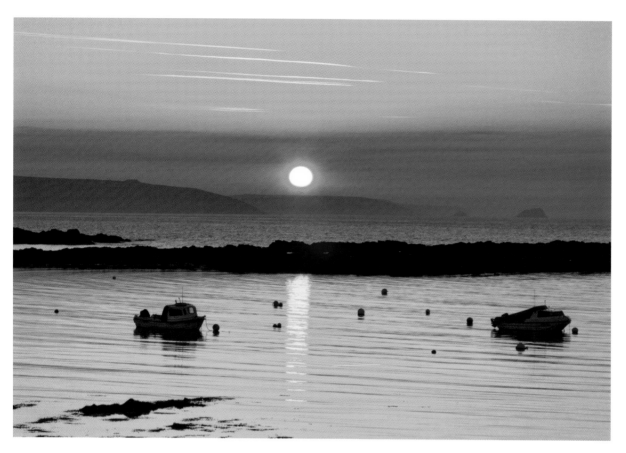

Old Head of Kinsale

The Old Head of Kinsale juts out into the Atlantic on a long promontory of land with splendid views all along the southern coast of county Cork. The headland is surrounded by high sandstone cliffs with a black-and-white striped lighthouse at the tip of the peninsula. The Old Head of Kinsale is most famous for being the closest land point to the site where the *Lusitania* sank in May 1915.

Sunrise near the Old Head of Kinsale.

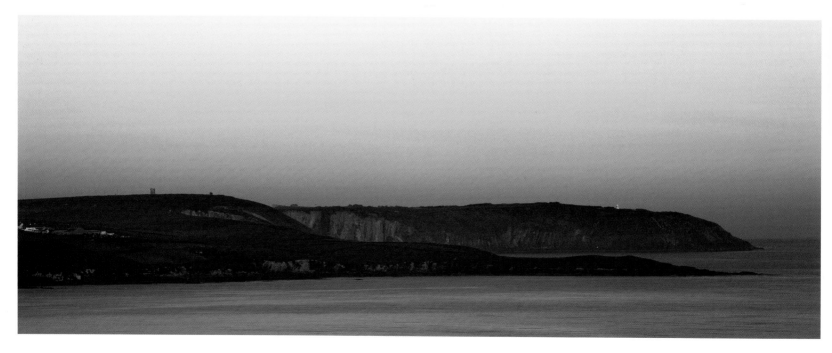

Garretstown

Garretstown lies a few minutes west of the Old Head of Kinsale. Garretstown Beach is one of Cork's finest sandy strands. Owing to its south-westerly aspect, the beach is a popular spot for surfers, who come from far and wide to ride the waves.

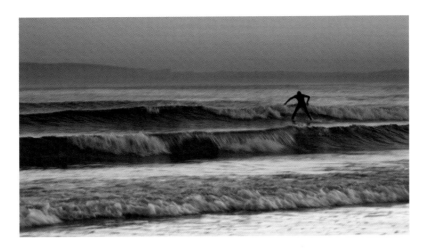

Surfing at sunset at Garretstown.

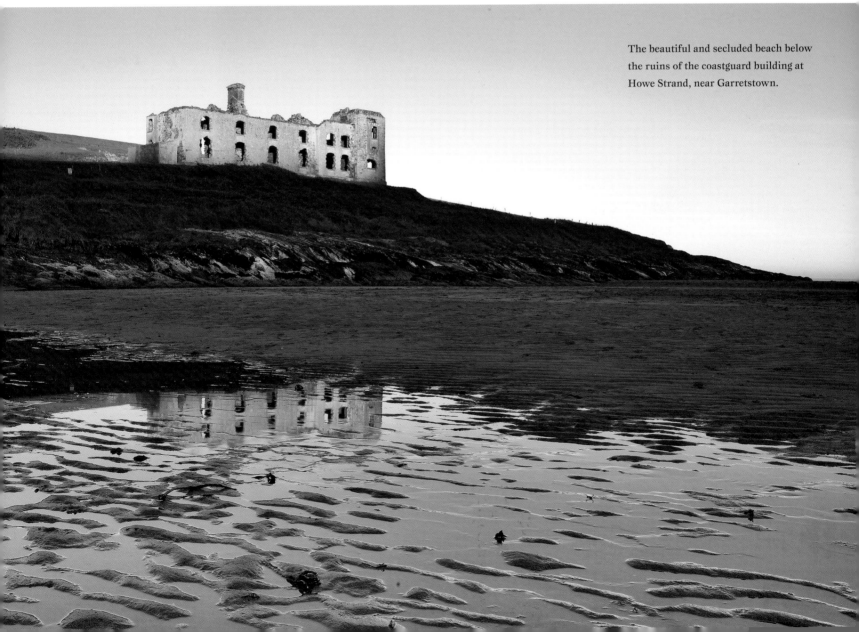

The beautiful and secluded beach below the ruins of the coastguard building at Howe Strand, near Garretstown.

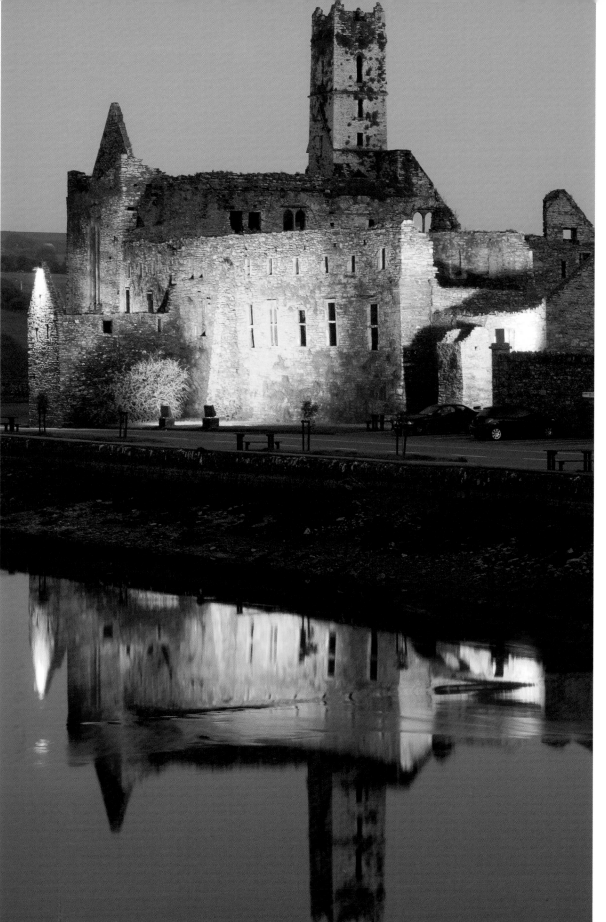

Timoleague Abbey

Timoleague (from the Irish, *Tigh Molaga* or the 'House of Molaga') is best known for the haunting ruins of a Franciscan abbey which is one of the largest of its kind in Ireland. It was founded in 1240, on a site already associated with St Molaga. The abbey was nominally suppressed in the reign of Henry VIII, but flourished into the first half of the seventeenth century. The ruins are perched on the edge of the sea at the top of the western arm of Courtmacsherry Bay. A curious feature of the ruins is a 2m feature known as 'The Squint'; it is thought that it was used by lepers, who lived in a retreat a mile distant, to enable them to participate in the Divine Mysteries in the only way that was allowed to them.

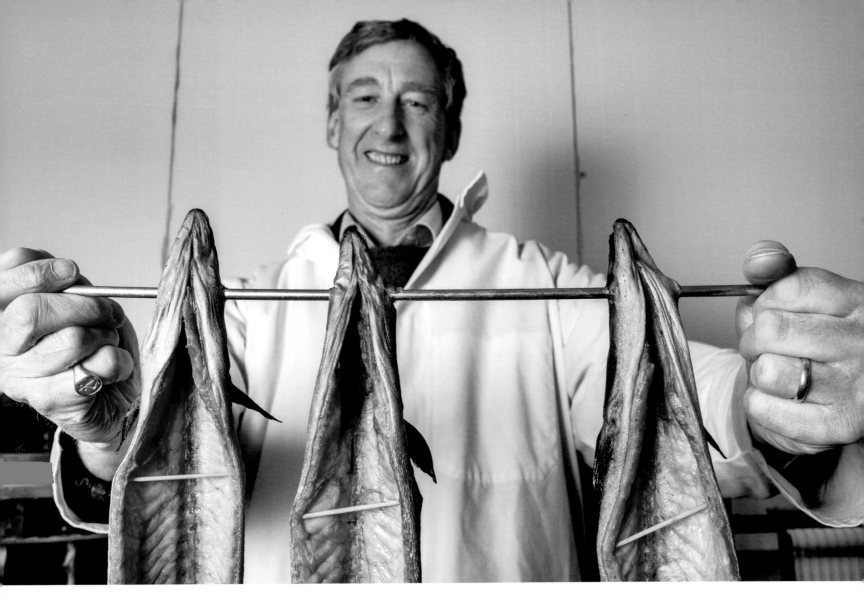

Ummera Smoked Products

In food circles Timoleague is becoming known as home to Anthony Creswell's Ummera Smoked Products. Since the 1970s, Ummera has grown a reputation for producing some of the finest smoked salmon available. They also produce organic gravadlax, smoked eel, smoked chicken, smoked duck and smoked dry-cured bacon – all with no artificial preservatives.

It was Anthony's father who started by smoking the salmon he was catching in the local rivers during the 1970s and, after much trial and error, he perfected methods which remain unchanged today.

The modern Ummera, however, is very much the manifestation of ideas conceived by Anthony. Since taking over in 1998, he has moved the business to a wonderful wooden-fronted new custom-built smokehouse, 1km upstream of its original location on the river and expanded the range of products available.

Of special note is the new smoked duck from Ummera which, after only twelve months of the first trial batch, has won a Three Star, Gold Award at the Great Taste Awards 2010, organised by the Guild of Fine Food in the UK.

Anthony has certainly taken the business into the twenty-first century and now sells his produce across the world. Ummera products are available to buy online.

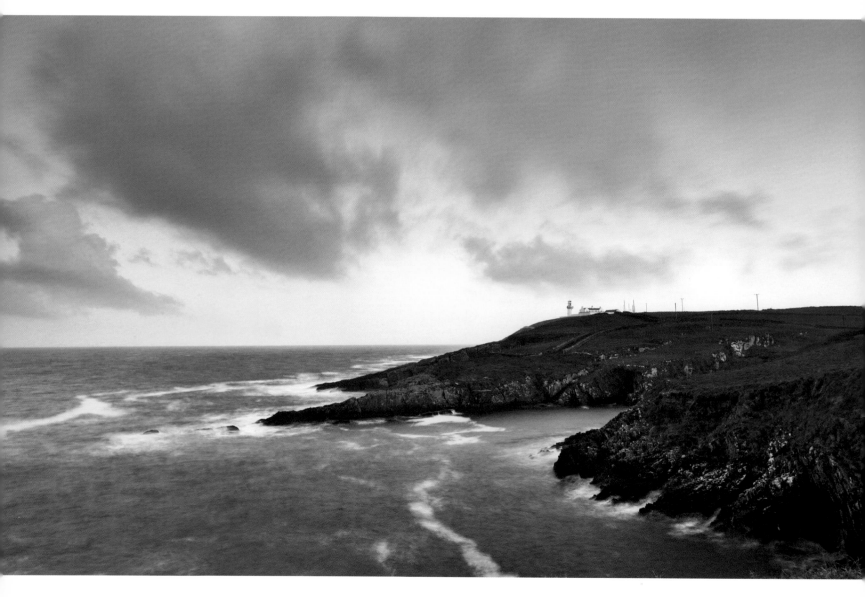

Galley Head

The impressive Galley Head lighthouse, built in 1875, overlooks St George's Channel and two sandy beaches, Red Strand and Long Strand. Legend has it that, at the request of the Sultan of Turkey, the lighthouse (one of the most powerful in Ireland) sends light much more inland than other lighthouses because the sultan wanted to view it from his guest abode at nearby Castlefreke.

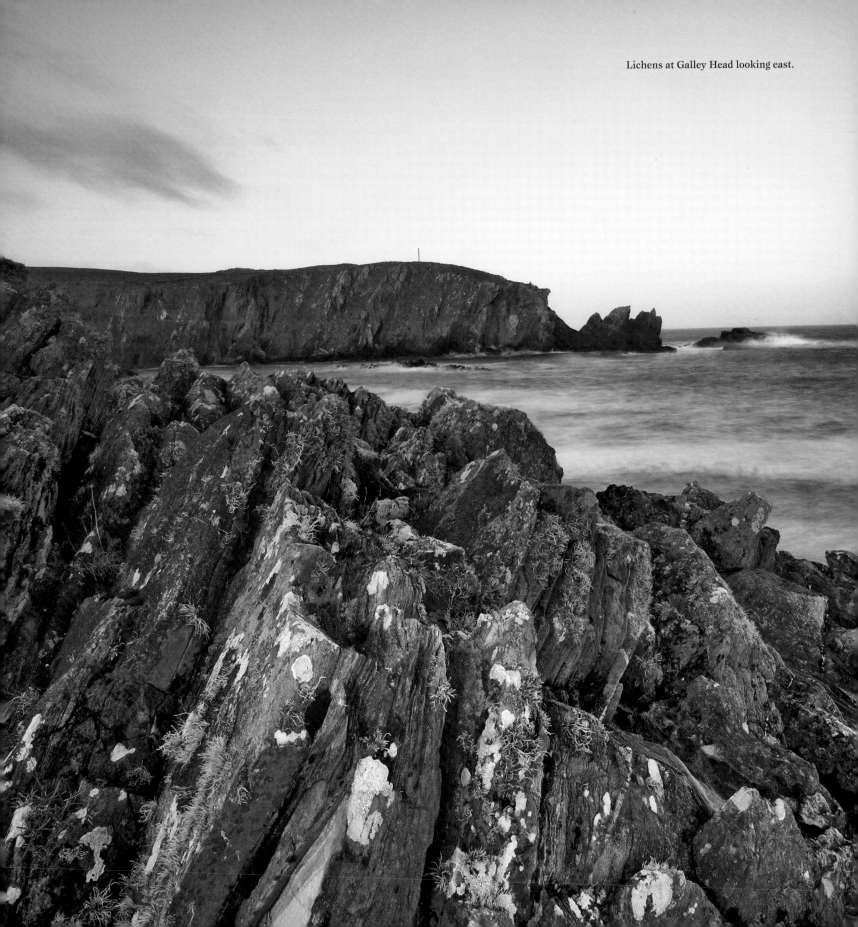

Lichens at Galley Head looking east.

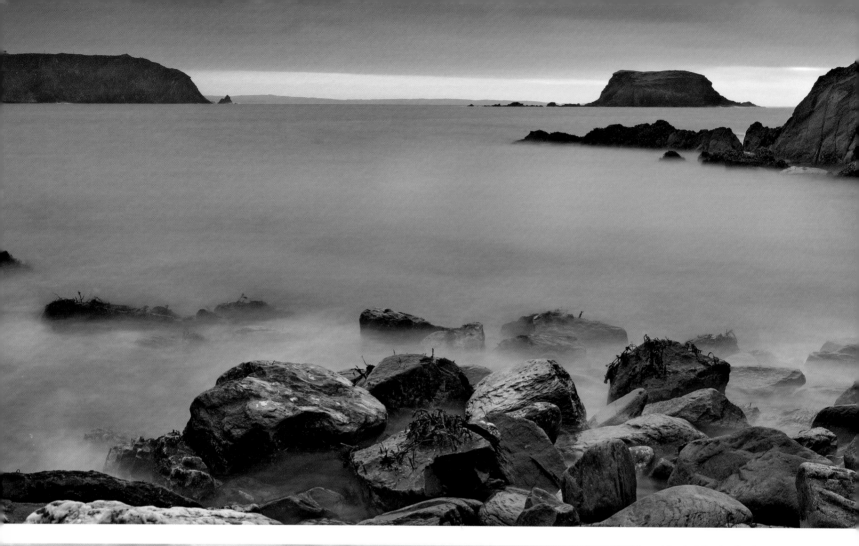

Adam's Island, Glandore.

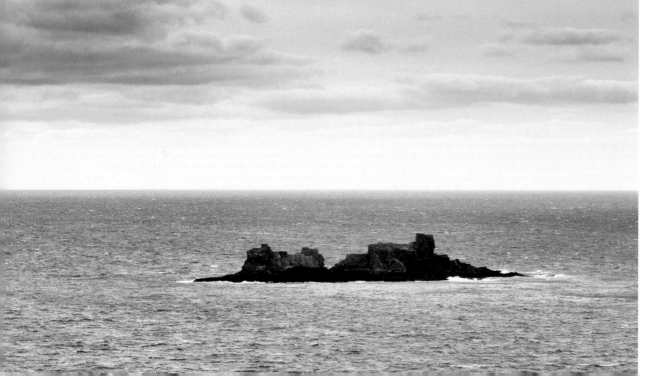

The Stags off the coast at Toe Head.
Many sea stacks are to be found off the
coast of Ireland, but the word 'stacks'
has been slurred to 'stags' in the locality.

Glandore

This view of Adam's Island, Glandore Harbour, is taken early in the morning, with a slow shutter speed used to blur the waters. The sun was coming up, causing an orange glow under the heavy cloud. Light in the morning is often very blue, with a colour temperature of approximately 9,000 kelvins (neutral daylight is 5,200 kelvins, sunset around 3,000 kelvins). Light scattering is an important natural phenomenon for me as a photographer; as the sun crosses the sky, it may appear to be red, orange, yellow or white, depending on its position. This is because of the scattering of light. The blue colour of the sky is caused by a process called Rayleigh scattering, which scatters blue light more than red.

And this morning the light is being well scattered as blue is the dominant colour. In the frame we have Adam's Island providing the focal point in the distance and Goat's Head getting in on the scene to the left of frame.

The modern village of Glandore (*Cuan D'or*, meaning 'Harbour of Gold' or Cuan Daire, meaning 'Harbour of Oak'), sits amongst some of the most interesting coast line in the county; Glandore Harbour is populated by Adam's and Eve Islands; further along the coast there is Sheela's Rocks, Stack of Beans, Rabbit Island and Seal Rock.

Glandore bursts into life in summer, when those with a passion for sailing arrive. The idyllic sailing-filled summer days are in stark contrast to the socialist commune established by William Thompson (1785–1833) as a model for his socialist philosophy.

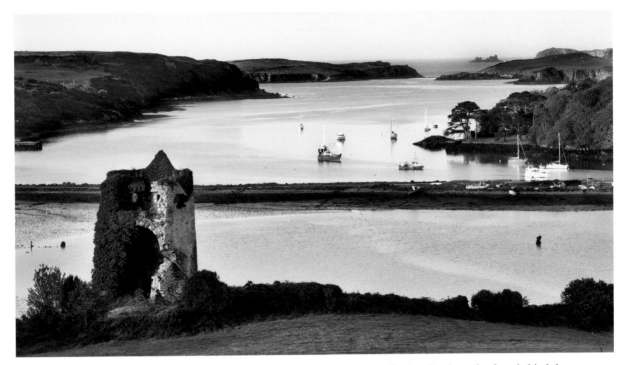

Castle Haven with The Stags in the distance. This image is called 'Harbour Guardian' as the viewpoint from behind the now ruined tower gives a sense of the superb view of the goings on that were witnessed by the watchtower's inhabitants.

Fishing boats by Union Hall.

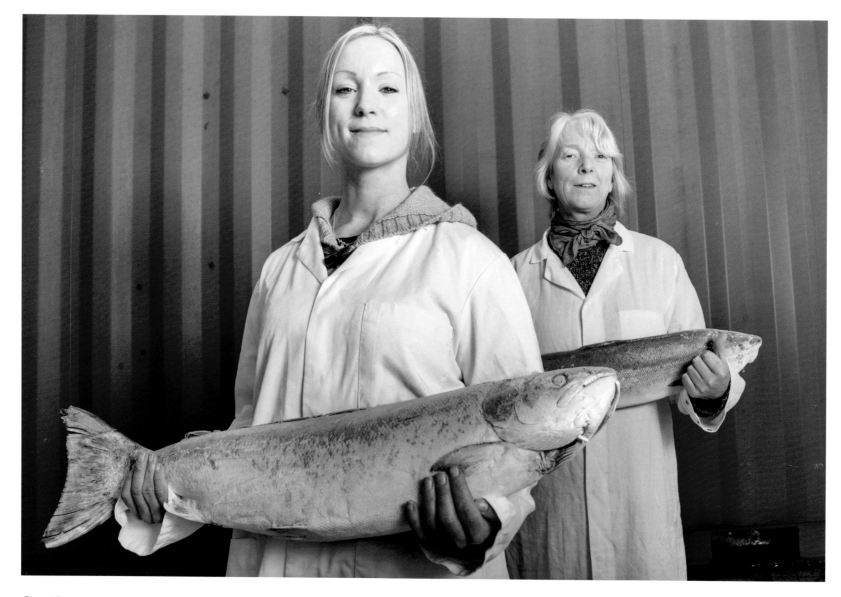

Castletownsend

Castletownsend is a town famous as being the home of Edith Sommerville, author of *Reminiscences of an Irish RM*. She is buried in the grounds of the Church of Ireland in the middle of the village. The Townsend family from which the village gets its name still live there and it is possible to stay in the castle, which is now a B&B.

Located on the outskirts of the Georgian village of Castletownsend, is Sally Barnes' Woodcock Smokery. The smokery sits atop a hill overlooking

the impressive standing stones known as 'The Fingers'. The area is full of souterrain passageways said to link the stone forts in the area, such as Knockdrum Fort nearby.

Sally Barnes and her daughter Joleine run the smokery and they epitomise the word artisanal. Sally has a wealth of specialist knowledge on fish and smoking fish that she is only too willing to share. In fact, Sally runs courses on smoking fish and she also explained the importance of having line-caught tuna

as opposed to net-caught tuna. This knowledge is not just academic for Sally it is 'essential' for producing the finest quality produce.

Sally has passed her knowledge down to Joleine, who carries the tradition on for a new generation. Already the Barnes ladies are specialists in the production of slow-smoked, fresh, wild-caught fish devoid of any artificial additives or preservatives and they cure their products in a traditional manner. This takes prime quality fish, native

hardwood timbers, skill and time. All aspects of the process, such as filleting, salting, pin-boning, and slicing, are done by hand in their smokery in Castletownsend. They are best known for their exceptional award-winning wild smoked salmon but also provide a wide range of smoked fish products including tuna, mackerel, herring, haddock and pollack using both hot and cold-smoking techniques.

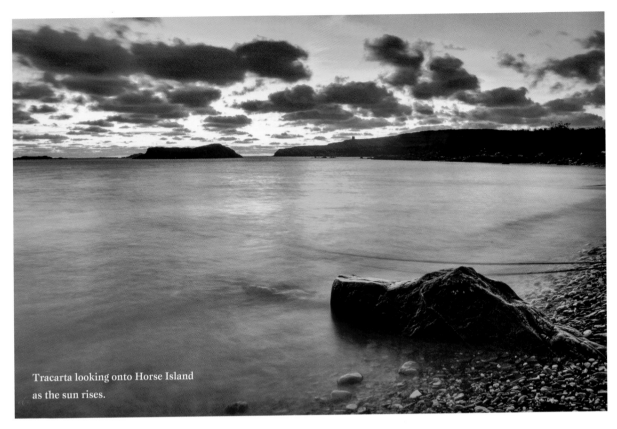

Tracarta looking onto Horse Island
as the sun rises.

Tracarta

An early rise at Tracarta and the sky
is a magnificent red. This east-facing
beach is excellent to watch the rising
sun, plus there is the added bonus of
the watchtower on Horse Island in the
distance, which was built as a landmark
for ships on their return from the West
Indies. Four Spanish bronze cannons
were discovered by a diver off the island
in 1970 and were evidently all that
remained of an earlier shipwreck.

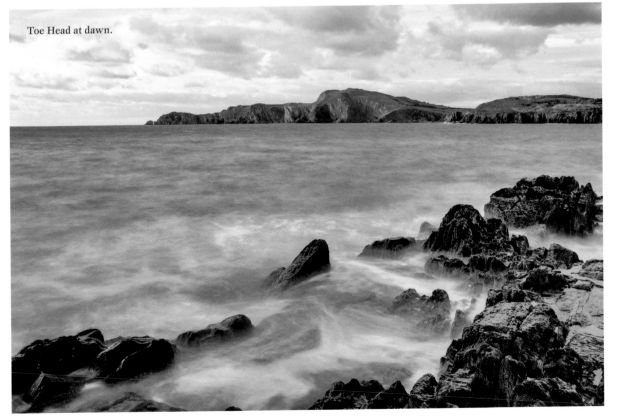

Toe Head at dawn.

Carrigillihy.

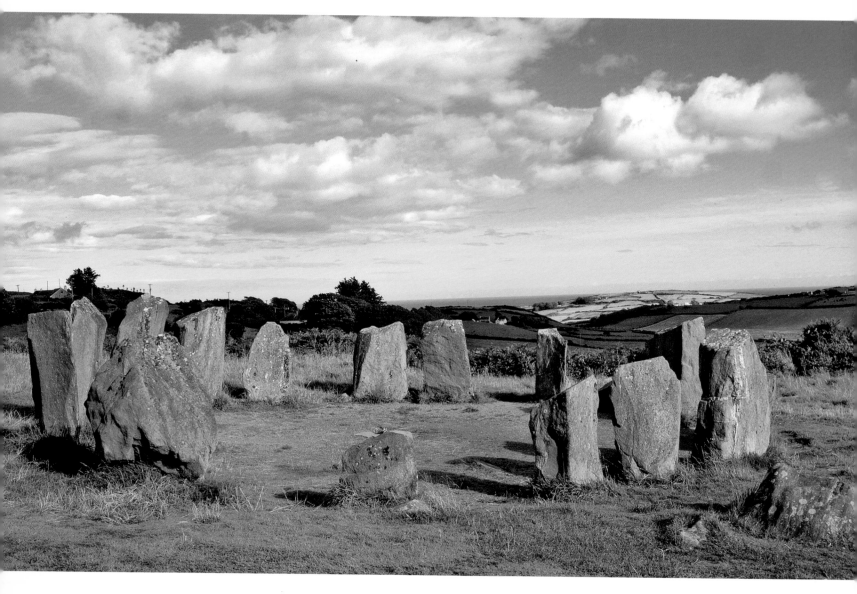

Drombeg Stone Circle

Of the many stone circles in West Cork, this particular group of seventeen stones, dating from around 100 BC and excavated in 1957, is particularly impressive, not least because of its stunning setting. On the south-western side a horizontal stone, (the axial stone), with ancient markings carved on it, faces two taller stones, (portal stones), on the north-eastern side. The axis of these two stones and the recumbent one is aligned to sunset on the winter solstice (21 December).

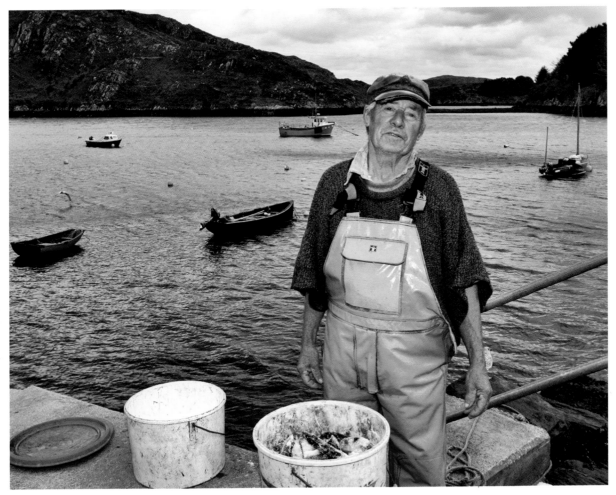

Lough Hyne

Lough Hyne is one of County Cork's most unusual areas of natural ecology. The lake is Europe's only seawater lake. After the last ice age, when sea levels were gradually rising, this hillside lough became exposed to the encroaching ocean. However, an almost complete wall of rock holds the sea back, only allowing it access through a narrow channel between the two bodies of water. Consequently, at high tide seawater flows into the lake and at low tide the lake's waters flow out. The upshot of his phenomenon and the lake's deep waters (up to 50m) means that Lough Hyne is able to support sea creatures more common in much warmer waters such as coral, sea-urchins and sponges.

After arriving at Lough Hyne in the middle of the day on a scouting mission for locations a chance meeting upon this fisherman salting up his freshly caught mackerel resulted in this shot. The fisherman informed me that the black tar boat behind him was 100 years old and belonged to his grandfather.

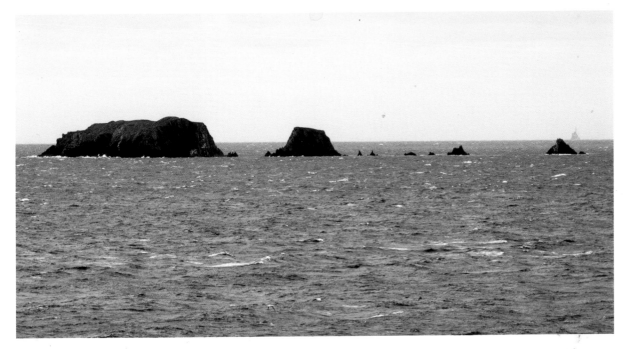

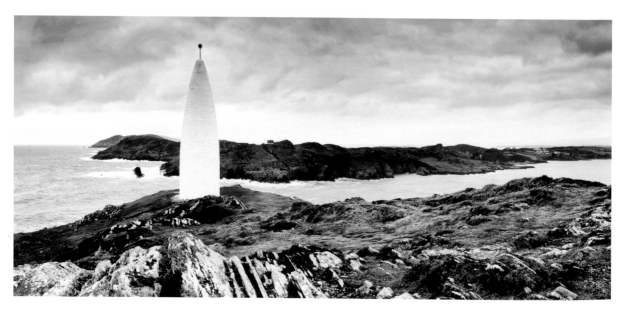

Baltimore & Skibbereen

Situated on the well-sheltered bay of that name, Baltimore is a notable fishing town that has a stirring history. The town and the castle of the O'Driscolls, which crowns a rock near the pier, were sacked by the men of Waterford in 1537 in revenge for the seizing by the O'Driscolls of one of their ships that was sheltering in the harbour earlier that year. Almost 100 years later, pirates from Algiers, led by a Dungarvan fisherman, who was afterwards executed at Cork, made a descent upon the restored town, razed it to the ground and carried off many persons, who were later sold as slaves in Algiers. Baltimore today becomes home during the summer months to sailing folk, anglers, divers and visitors to Sherkin and Cape Clear Islands. A stroll to the Baltimore beacon at sunset gives some beautiful views of the outlying islands. Skibbereen is an important market town on the River Ilen, whose winding estuary meanders out to Roaringwater Bay a couple of kilometres away. The town owes its existence to the Algerian pirates; the frightened settlers moved inland and founded a village that later grew into Skibbereen.

Roaringwater Bay

Roaringwater Bay is a beautiful area of West Cork that is famous for its many islands. Some of the islands such as Sherkin Island and Heir Island remain inhabited. Fish farming is an important industry for the bay and the tell-tales signs of their nets can be seen everywhere. The eastern landward end is a network of tiny lanes lined with fuchsia hedgerows with an occasional glimpse visible across the bay. Mount Gabriel near Schull dominates the northern edge of Roaringwater Bay.

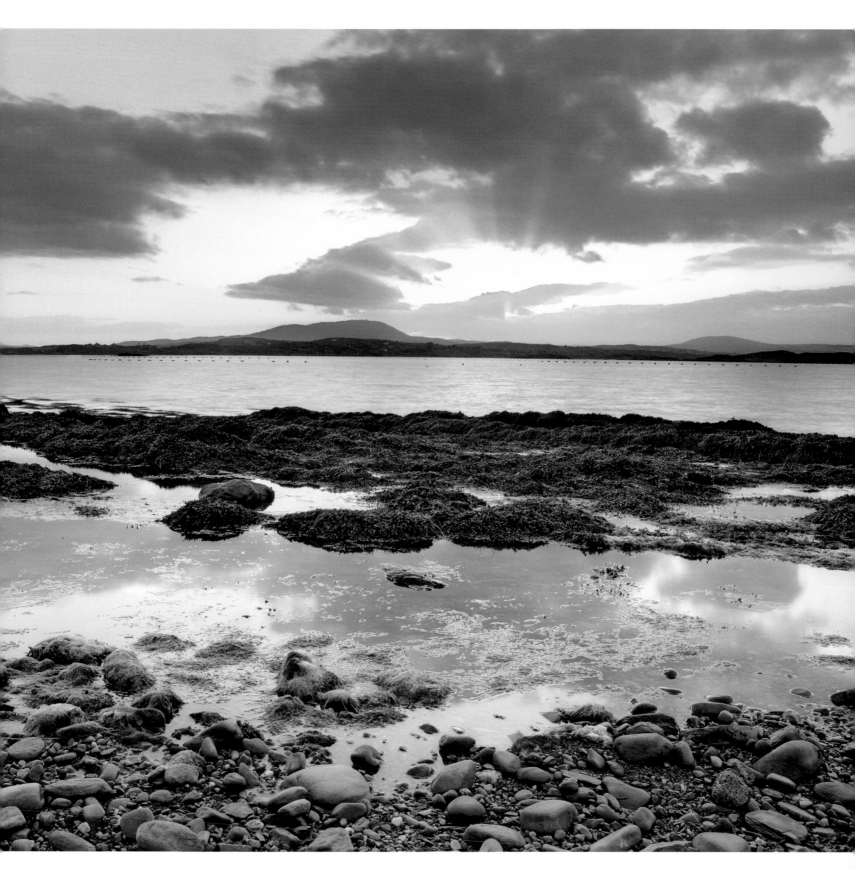

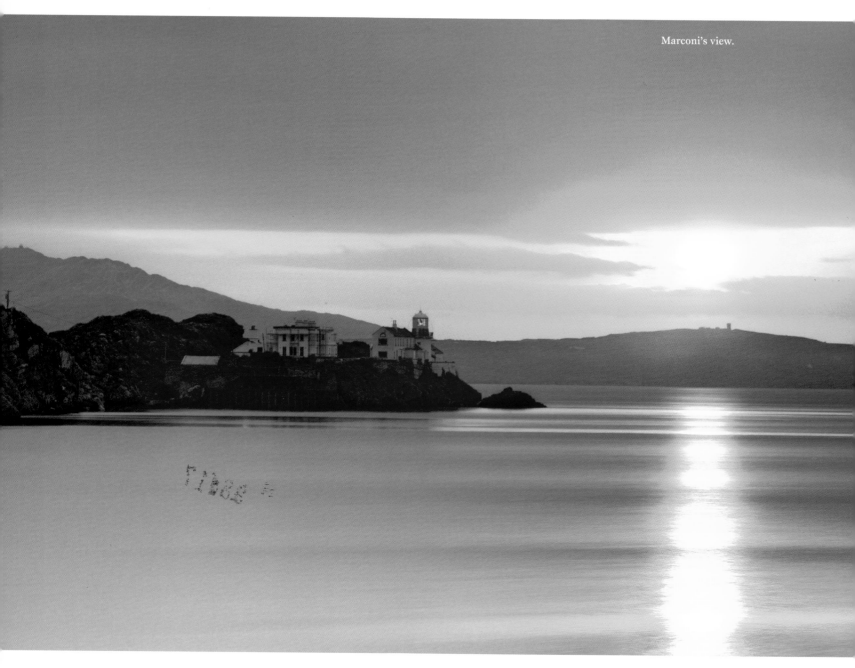

Marconi's view.

Crookhaven

This shot was seven years in the making! The first attempt at this view was an unsatisfactory watercolour painting. However, on this morning all the elements of a perfect image came together, with the rising sun to the right of the lighthouse the focal point in the scene. It was particularly satisfying given the 4 a.m. rise to travel to the location. The image was taken at Crookhaven, a picturesque harbour village in West Cork.

Crookhaven was once very important as the most westerly harbour along the southern Irish coast. Mail from America was collected here and the nearby Brow Head has a ruined observation tower on the summit from where Gugliemo Marconi transmitted his first message (to Cornwall) and received a reply.

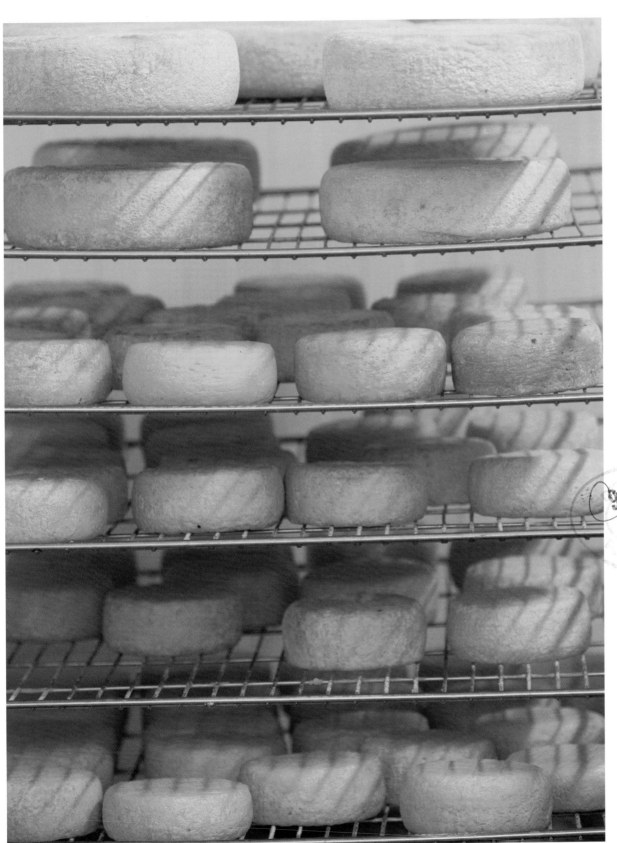

Durrus Cheese

Durrus Farmhouse Cheese is a raw milk cheese made using traditional methods in an upland valley on the Sheep's Head Peninsula. The cheese has been handmade by Jeffa Gill since 1979 and it is recognised as one of the finest modern Irish Farmhouse Cheeses made by traditional methods. Durrus farmhouse cheese has won numerous medals and awards around the world.

The cheese is a deep-flavoured semi-hard rind washed cheese made from the milk of local West Cork dairy herds. It has a creamy texture and a milky, fruity flavour. The older cheese has a more challenging flavour with seasonal flavours coming through on the palate.

It is possible to visit the farm during the week to view the cheese-making process and to buy some Durrus Farmhouse Cheese directly from the dairy.

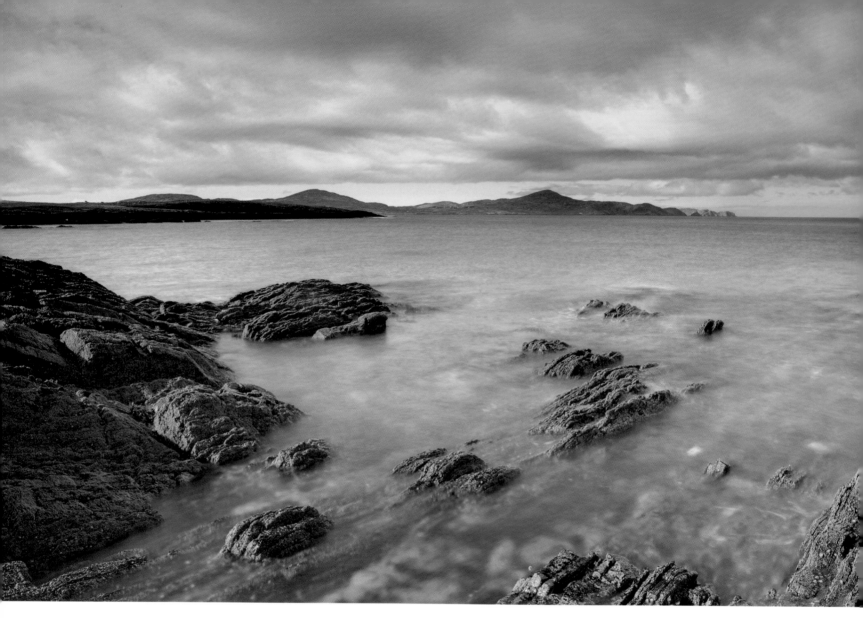

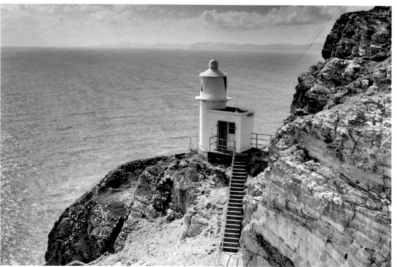

Sheep's Head

The Sheep's Head Peninsula could possibly be described as one of the great forgotten peninsulas of Ireland. Much less well known than its more famous neighbours the Beara Peninsula and Kerry's Iveragh Peninsula, the Sheep's Head Peninsula sticks out at the bottom of Ireland like a tool in a Swiss army knife. The western extremity of the Sheep's Head Peninsula is a wild and empty land. The point where land finally gives way to sea is marked by a small lighthouse. Views from the lighthouse are wonderful with Dunmanus Bay and Mizen Head dominating to the south and the mountains of Bere Island and the Beara Peninsula rising across Bantry Bay to the north.

Ahakista

Ahakista is situated on the northern shore of Dunmanus Bay on the Sheep's Head Peninsula. It has a sandy beach, fine views and is home to a small vibrantly-coloured fishing fleet.

Close to Ahakista stands a curious tower built by Lord Bandon to match the O'Mahony Tower on the southern side of Dunmanus Bay. Lord Bandon did not copy the medieval O'Mahony style of architecture since his castle folly has large windows and three superfluous medieval chimneys.

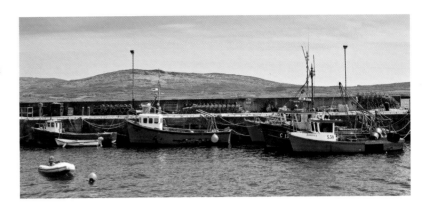

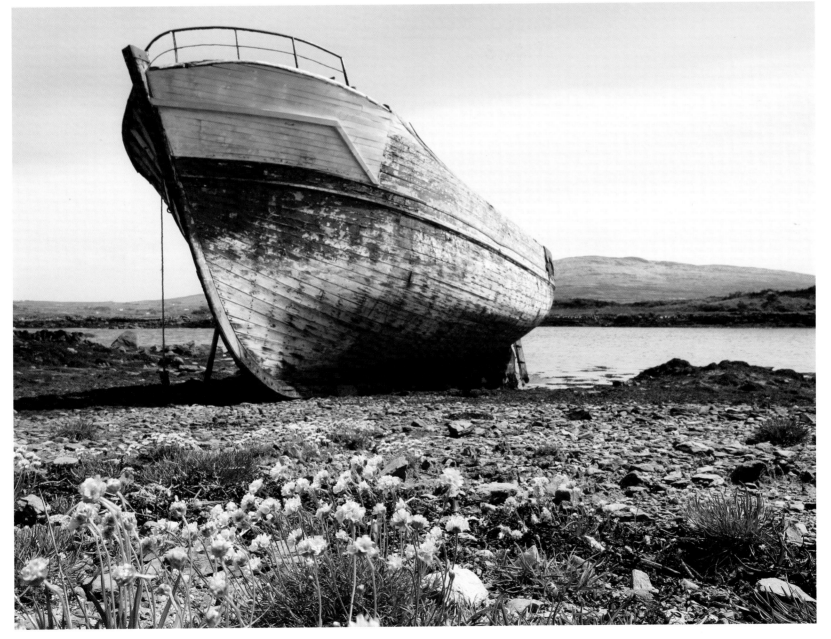

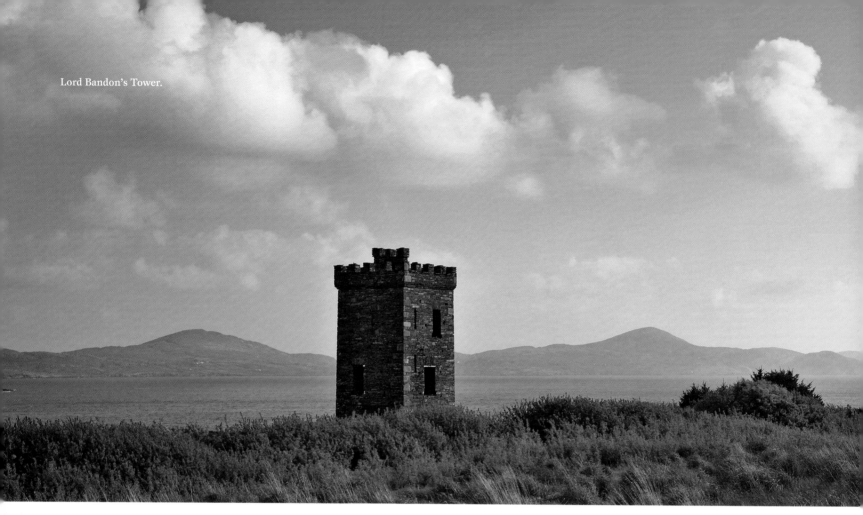

Lord Bandon's Tower.

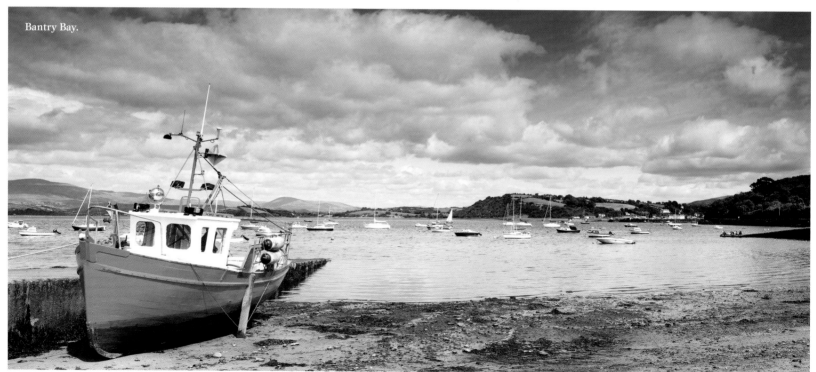

Bantry Bay.

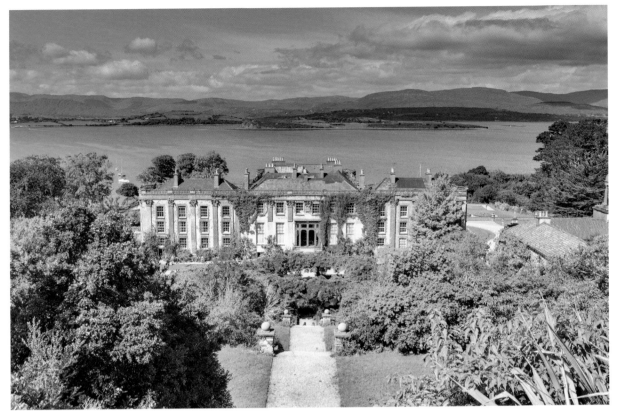

Bantry House

Bantry is nestled in a set of hills at the eastern end of Bantry Bay. Before Irish independence, Bantry Bay was a major anchorage for the Royal Navy. The bay's deep waters were exploited by Gulf Oil, who built an oil terminal on Whiddy Island, just off-shore from the town. Fifty-one lives were lost in 1979 when a fire broke out at the oil terminal.

Bantry narrowly missed fame in the late-eighteenth century, thanks to storms that prevented a French fleet led by Wolfe Tone from landing to join the United Irishmen's rebellion of 1798. A local Englishman by the name of Richard White was rewarded with a peerage for trying to alert the British military authorities in Cork. His grand home is open to the public and is the town's most celebrated tourist attraction. The gardens of Bantry House are its greatest glory and the formal Italian gardens at the rear have an enormous stairway offering spectacular views over the house and westwards over Bantry Bay.

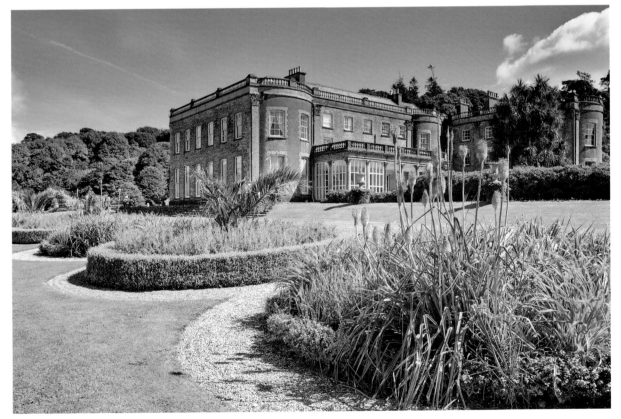

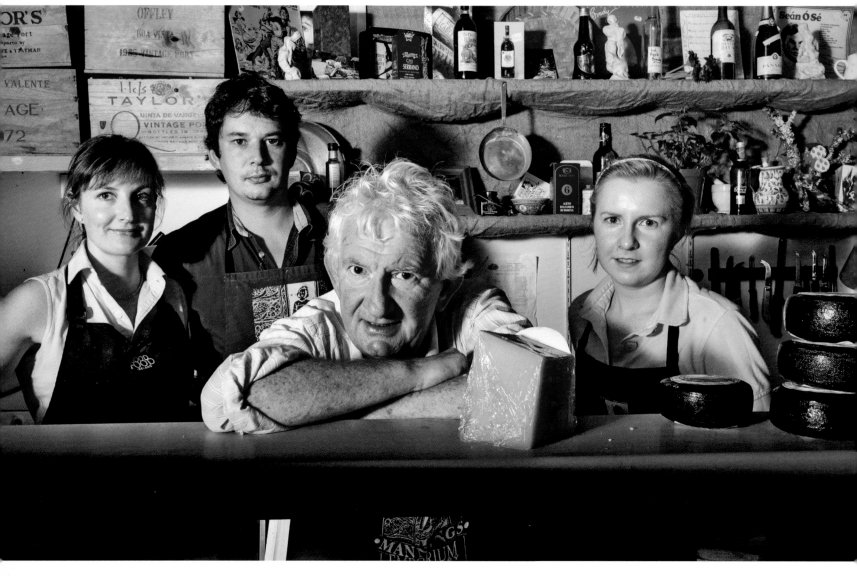

Manning's Emporium, Ballickey, Bantry

A visit to Manning's Emporium alone justifies a trip to County Cork. Situated along the roadside in Ballylickey near Bantry, Manning's Emporium is a gourmet's oasis. Val Manning is a big reason the West Cork artisanal produce is a success, being one of the first people to sell locally produced cheese back in the 1970s. Since then, the shop has supported countless other small producers and cheese makers.

What makes Manning's that bit extra special is the dining experience. Customers can choose their own 'lunch' from the wonderful produce on offer; the best option is to request Val makes you up something special. It is also recommended that customers order one of Val's cheese boards, which come in all manner of shapes from violins to birds, all made from wood.

What Manning's Emporium serves up is a non-fussy, casual and relaxed picnic area in which to enjoy some of the highest-quality gourmet food Ireland has to offer.

For those who would like to add some history to their visit to Ballylickey, there is a wonderful stone circle at Kealkil nearby. The Kealkil circle, situated on Maughanclea Hill, consists of a small stone circle, a cairn, and two large monoliths and provides spectacular views of Bantry Bay.

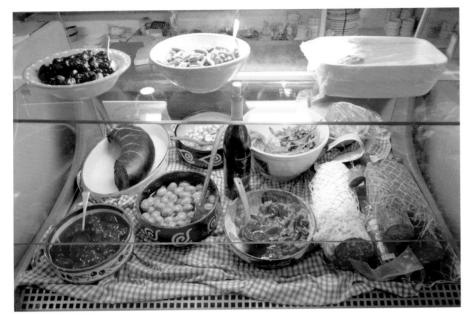

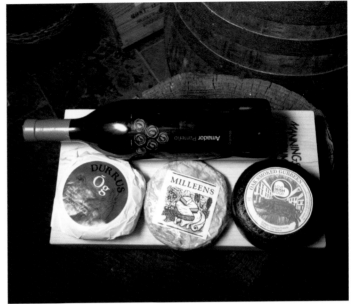

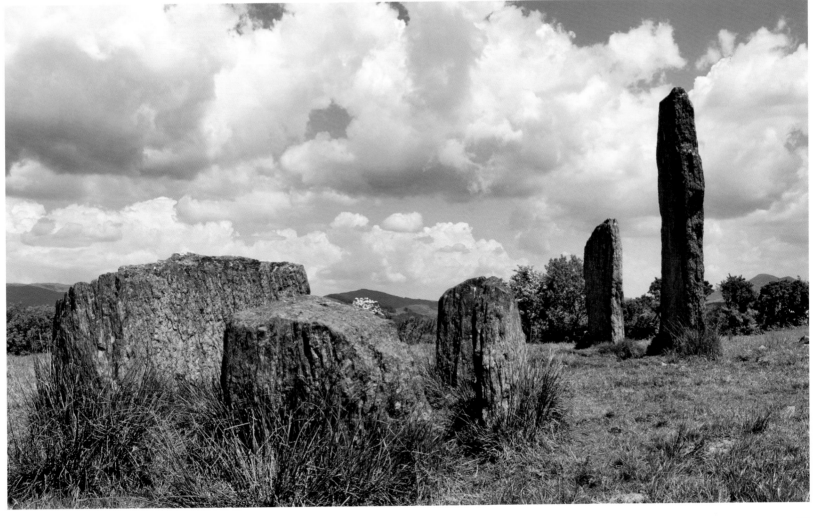

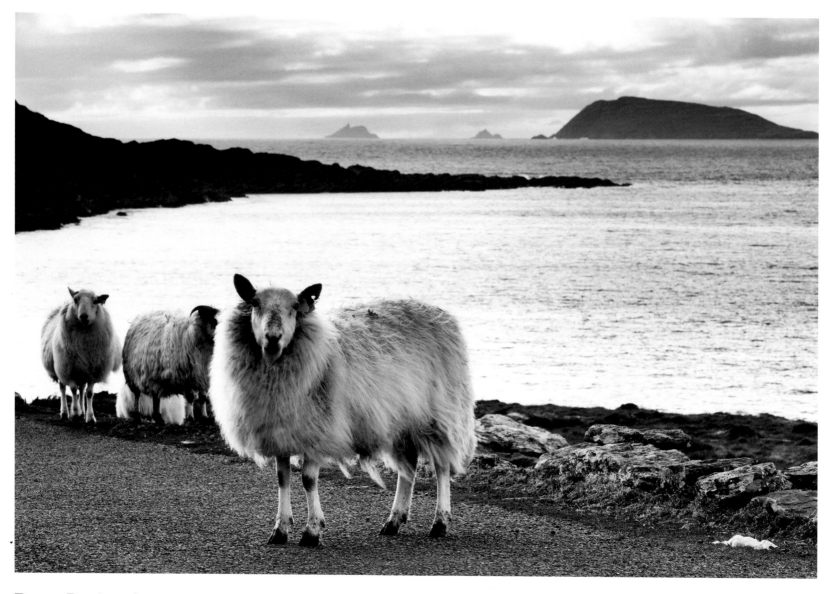

Beara Peninsula

The Beara Peninsula is, in terms of tourist numbers, a much overlooked peninsula, in contrast to its more famous neighbour, the Iveragh Peninsula. This fact is a double-edged sword, as greater tourist numbers would spoil the solitude and space of the Beara Peninsula. This is a world away from Cork City. For me, it is a place that seems to hold onto the soul of what we imagine Ireland should be, the Ireland that the tourists come here to find, with its wide open places, friendly people, mountains, great walks, scenery, sheep and solitude. This solitude is so marked that Beara has its own Buddhist retreat centre, 'Dzogchen Beara', set overlooking magnificent cliffs near Garranes.

A timeless image of Ireland near Urhan with the Skelligs in the distance, but very much present-day Beara.

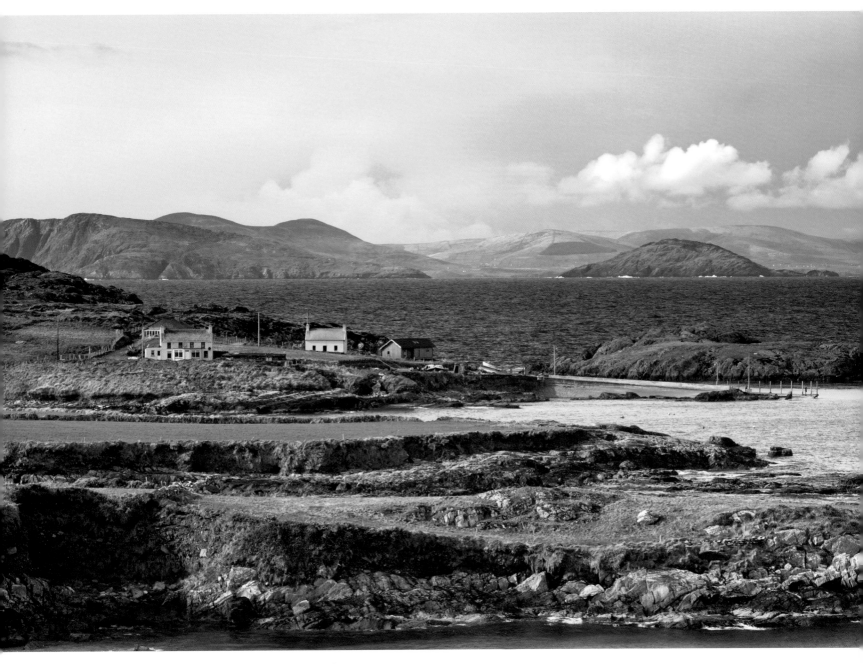

A classic Irish view near Garinish.

Allihies

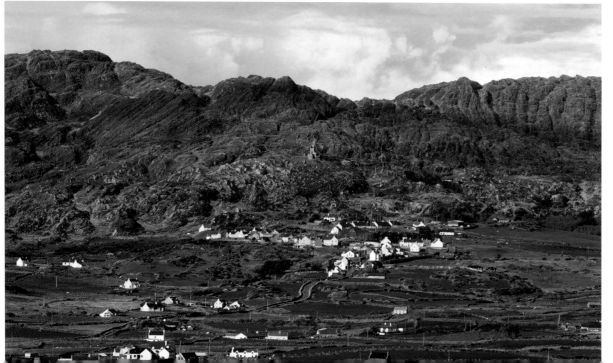

Allihies is situated near the western extremity of the Beara Peninsula, which is noted for its startling natural beauty. The village was once noted for its copper mines and the abandoned mineshafts are dotted across the hills overlooking the area. Copper was discovered in 1810 and experienced Cornish miners were brought into the area to work the rich seams of copper ore. The last mine closed in 1962. There are splendid marine views in the district, north towards the Iveragh Peninsula in County Kerry and the Sheeps Head, and Mizen Head Peninsulas to the south.

Black Ball Head

Black Ball Head lies a couple of kilometres west of Castletownberehaven. The solitude at the abandoned watchtower and the stunning views towards Crow Head make this a magical spot. Not far from Black Ball Head is also Ireland's only cable car, connecting Dursey Island to the mainland.

A view of the MacGillicuddy Reeks in the distance from near Ardgroom on the Beara Penninsula – perhaps the best view in Cork, a Kerryman might say. Milleens cheese, Ireland's first ever artisanal cheese, is made in nearby Eyeries.

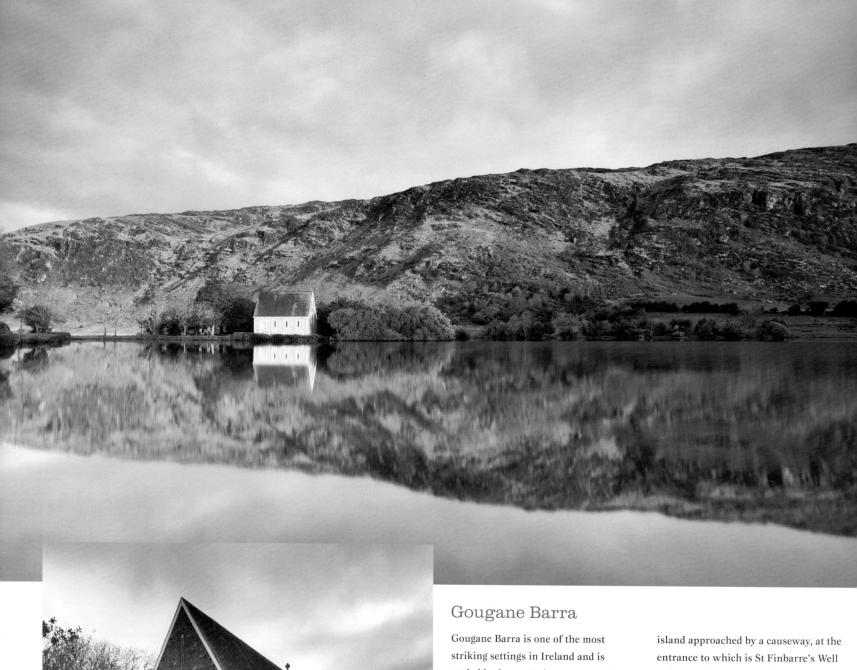

Gougane Barra

Gougane Barra is one of the most striking settings in Ireland and is probably the most picturesque part of inland Cork. Gougane Barra Lake is a romantic mountain lake fed by numerous silver streams and is the source of the River Lee. In this desolate region of West Cork, St Finbarre, a native of the locality, founded a monastery in the seventh century. He subsequently established a monastery 'where the waters of the River Lee meet the tide' in the marshy land of Cork, now the location of Cork City. In the middle of Gougane Barra Lake is an island approached by a causeway, at the entrance to which is St Finbarre's Well and an ancient cemetery held in great veneration. As Gougane Barra was an out-of-the-way spot, a Catholic church was tolerated even when the penal laws were at their strictest. People from all around the area travelled to Gougane Barra to attend services, arriving via routes known as 'mass paths'. A small modern church has been erected on the island. People still make the pilgrimage to commemorate the Festival of St Finbarre on the Sunday nearest to 25 September.

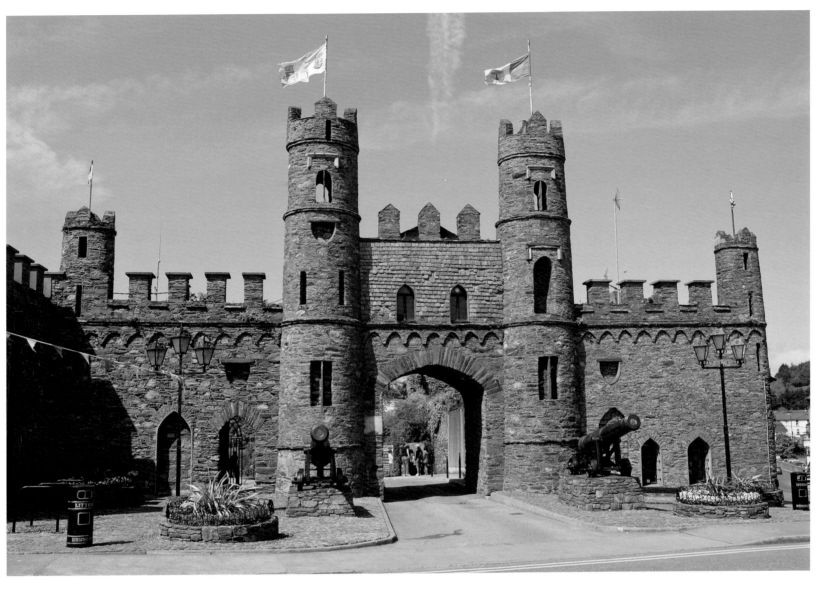

Macroom

Macroom is a town with a beautiful situation on the River Sullane, which flows into the River Lee, a short distance below the town. There are picturesque remains of a castle, a huge quadrangular keep, believed to have been built during the reign of King John. It withstood numerous sieges, and was burnt down no fewer than four times during the seventeenth-century wars. Local tradition has it that the father of the founder of Pennsylvania, William Penn, was born in Macroom Castle.

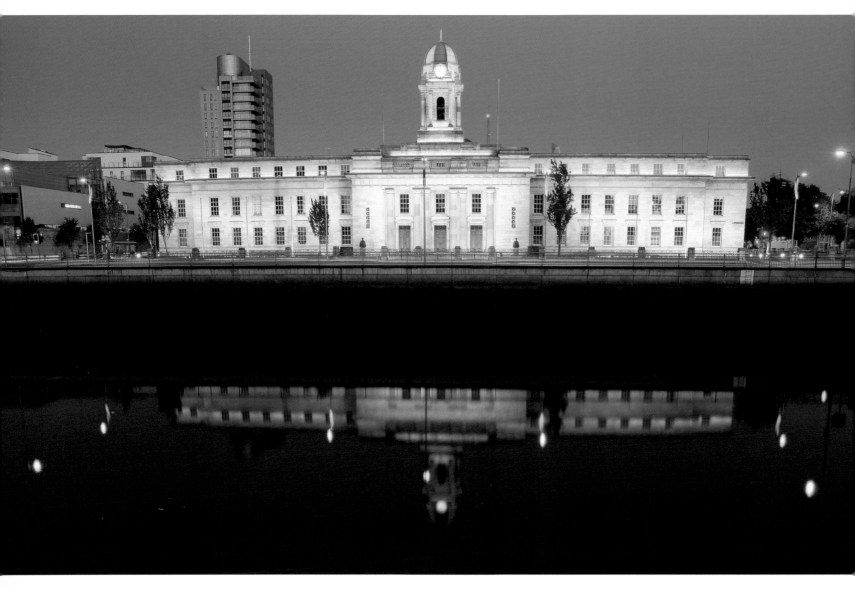

City Hall

Cork City Hall was rebuilt following
the burning of the original building
by the Black and Tans during the War
of Independence in September 1920.
The present building was rebuilt in
limestone and was formally opened by
Eamon De Valera in 1936. It is the home
of Cork Corporation, but it is also used
for concerts and fairs. The building is
particularly striking at night, when the
light of the columns and clock tower are
reflected in the waters of the River Lee.

2

CITY

Cork City, the Republic of Ireland's second city, stands on the River Lee close to its entry into Cork Harbour. It is an ancient city that was founded by St Finbarre from Gougane Barra. The city developed into an important European maritime and agricultural centre with butter being its most important export. Cork City is a charming and engaging place that bustles with visitors year round. The heart of the city revolves around the historic English Market, which is crammed with the smells and sounds of its thriving food industries.

The city's greatest natural treasure is Cork Harbour, lying to the south-east of the city. The harbour is mostly landlocked, apart from its narrow sea entrance at Roche's Point.

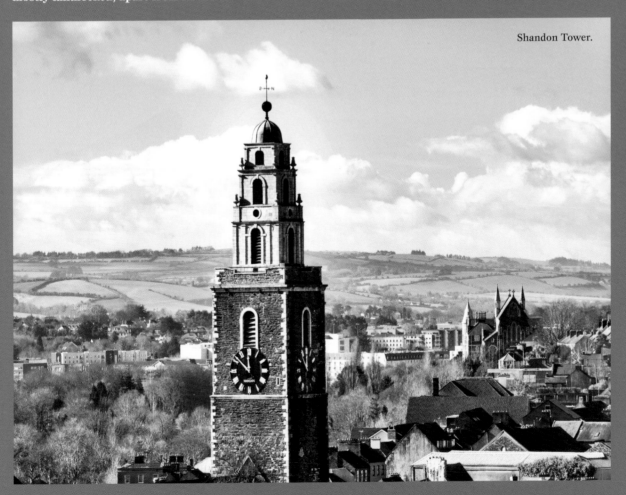

Shandon Tower.

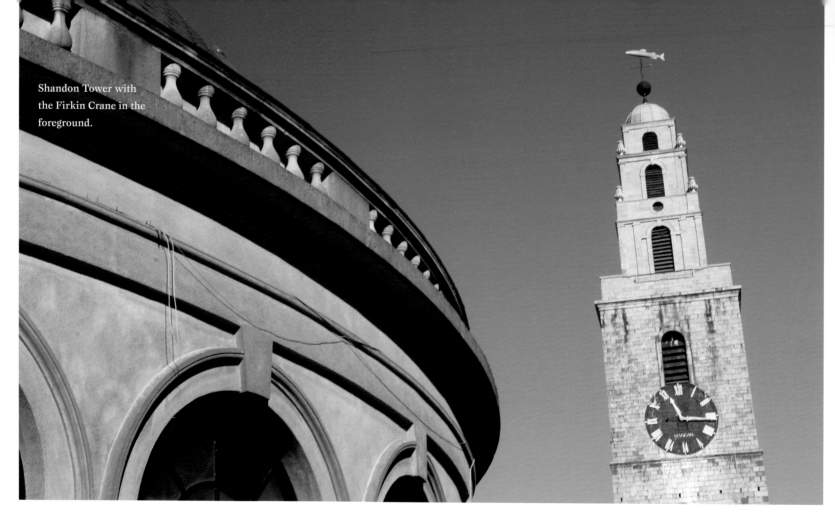

Shandon Tower with the Firkin Crane in the foreground.

Shandon Tower

The northern side of Cork City is dominated by the stepped tower of St Anne's church in Shandon, which was built on the site of a medieval church that was destroyed in 1690. The church is one of Cork City's premier tourist attractions, as tourists can climb the tower and ring the eight bells. Two of the tower walls are constructed in white-coloured limestone blocks and the other two are built with red-coloured sandstone blocks. These red and white colours were adopted by the Cork county football and hurling teams when the GAA was founded in the nineteenth century and the red and white are synonymous with County Cork on the sporting field.

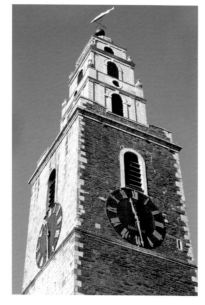

Shandon Tower showing its true colours, with its red and white faces.

The Butter Museum

The Firkin Crane Cork Butter Market was the epicentre of Cork's nineteenth-century prosperity. In the late eighteenth and early nineteenth centuries, Cork was home to the largest butter market in the world. Exports from here went to Europe, India, South America and Australia. Salted butter was brought to the market in wooden caskets called firkins made of oak and other hardwoods. The best firkins were made in Cork and these were compulsory for transporting butter to tropical parts of the world. Today the circular building has been restored as a dance centre and is now known as the Firkin Crane Centre. Buttered eggs are a Cork speciality (the butter being used to preserve the eggs).

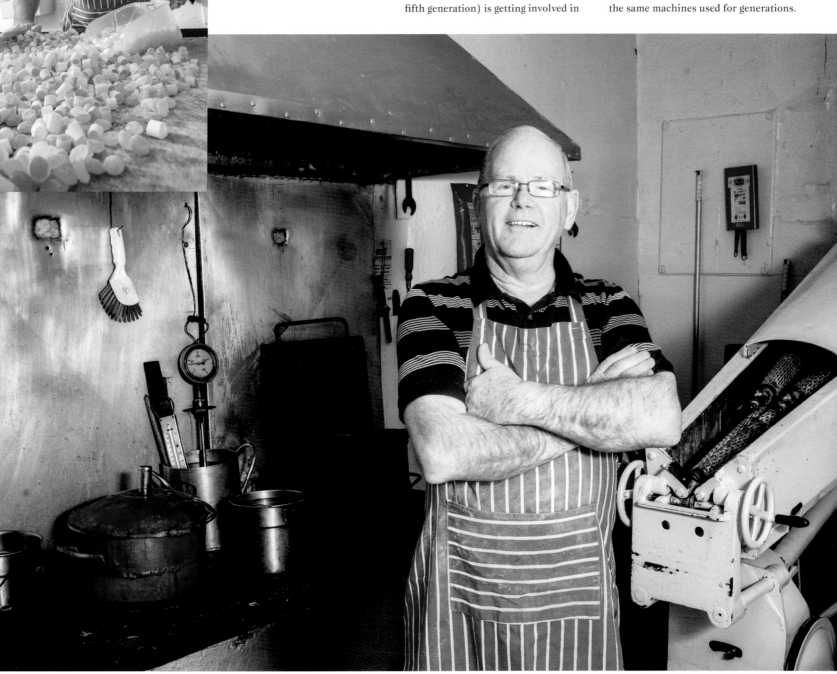

Linehan's Old Traditional Sweets

Linehan's handmade sweet factory is literally around the corner from Shandon Tower. Five generations of the Linehan family have been involved in making sweets in the factory. Danny Linehan runs the sweet factory with his son, Tony, and Tony's son (the fifth generation) is getting involved in the family business now. Walking into Linehan's is like stepping back into your own childhood. They make sweets such as clove rocks, pear drops, butter nuggets, cough drops and bull's eyes in the same way as Danny's grandfather did before him and all by hand, using the same machines used for generations.

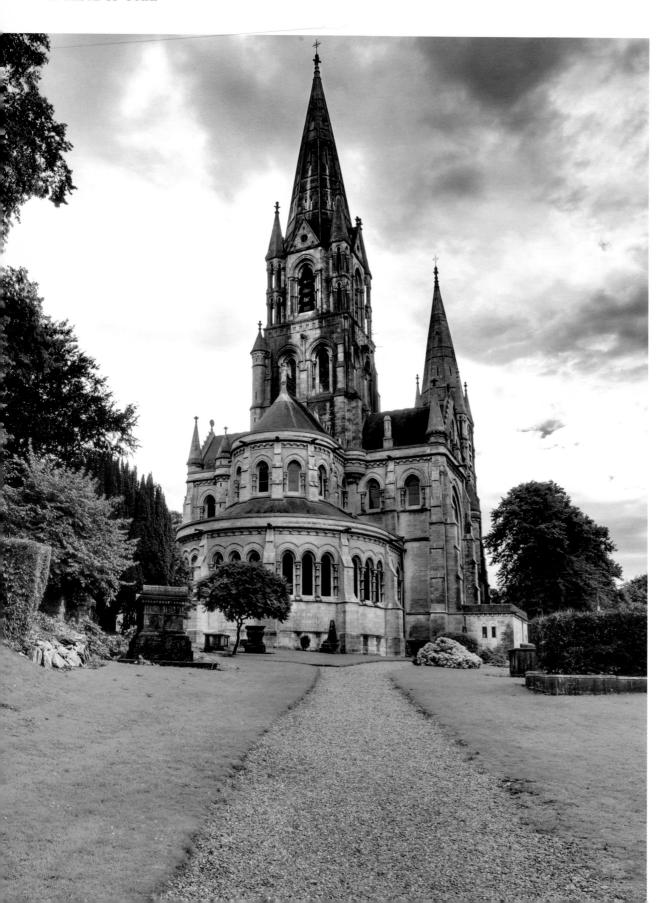

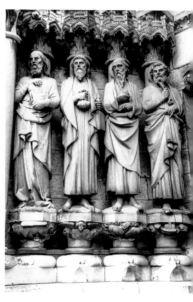

St Finbarre's Cathedral

Dramatically lit at night, St Finbarre's Cathedral is an imposing building that was designed by the Victorian architect William Burgess. Work was finished in 1879 to give a finished building with three spires and a high Victorian interior. On display inside the cathedral is a cannon ball fired from the nearby Elizabethan Fort during the siege of Cork in 1690; it was found embedded in the tower of the old medieval cathedral during construction of the new building.

A stunning feature of St Finbarre's is the golden resurrection angel which faces the city side. There is a local superstition which states that if the angel ever falls it would signify the end of the world.

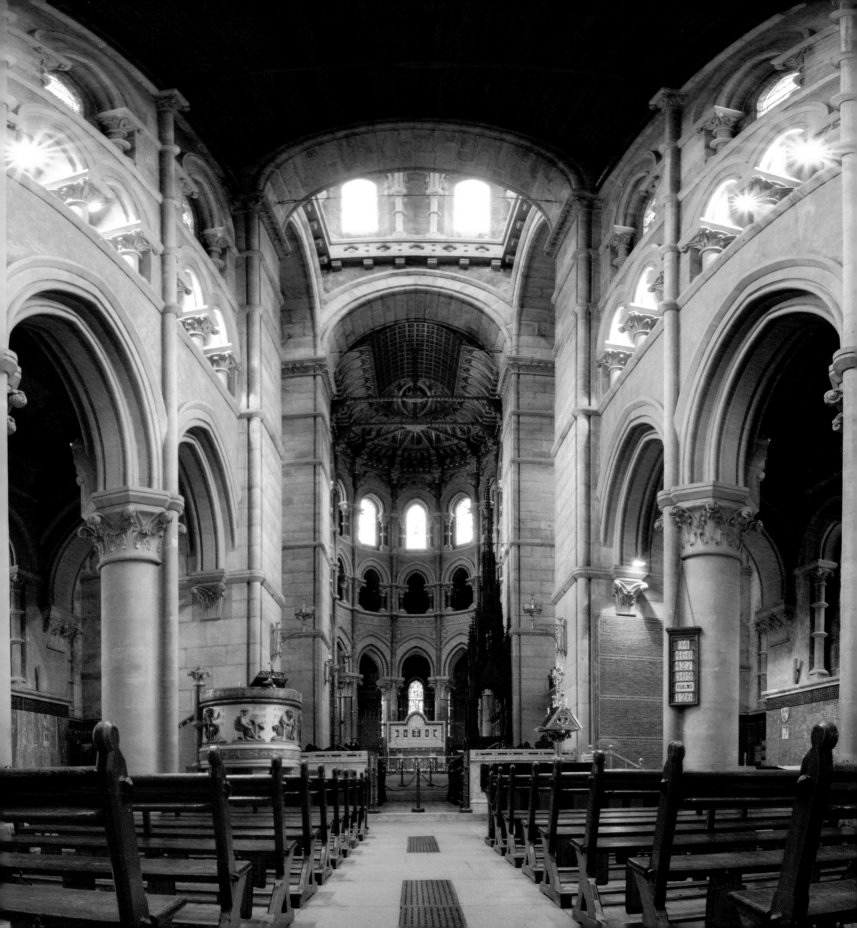

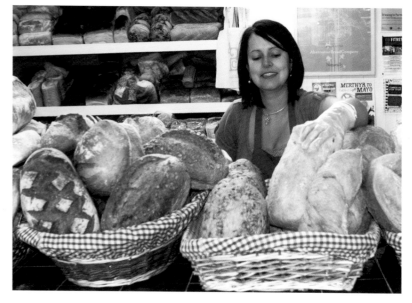

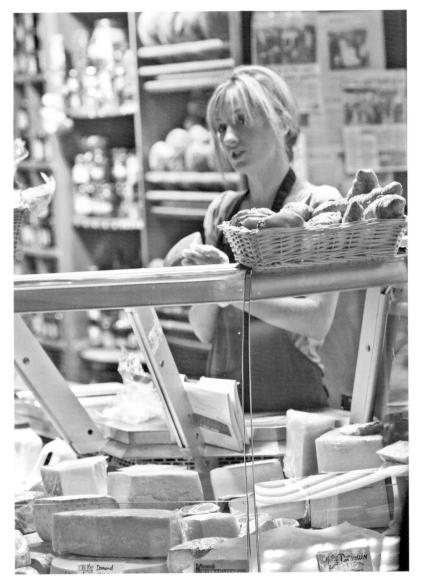

The English Market

The English Market is certainly the jewel in the crown of any foodie's visit to Cork. Trading as a market since 1788, it feels and looks very much like Barcelona's famous Boqueria Market, which it in fact pre-dates by almost eighty years. The hustle, bustle, colour and smells of the English Market are truly unique. The English Market is the culinary crossroads of the city, making it a *tour de force* of some of the best food produced in Ireland.

The market is packed with artisan butchers, cheese sellers, vegetable stalls and fresh fish, much of it from Ballycotton and West Cork. Chefs from many of the hotels and restaurants in Cork can be spotted choosing delicacies for the evening menu over the course of a day. The *Observer* newspaper has listed the English Market as one of the top ten food markets in Europe, but Corkonians reckon that it is the best.

Queen Elizabeth II herself visited the English Market on 20 May 2011 during her historic visit to Ireland.

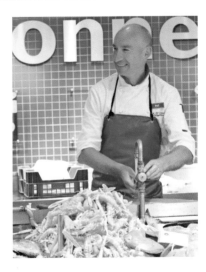

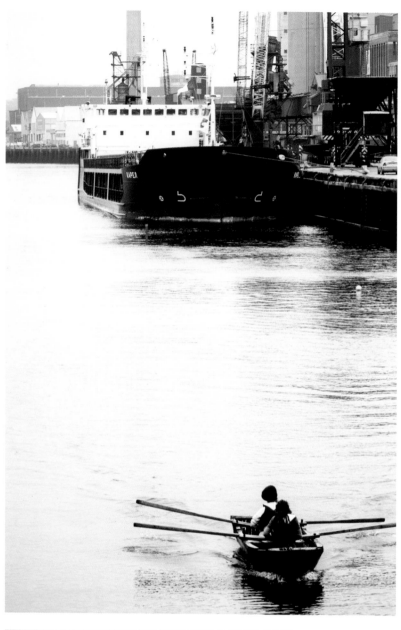

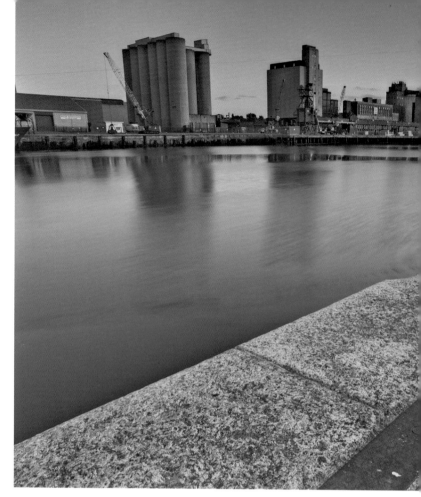

Cork Docks

All types of boat have been coming in and out of Cork's Harbour ever since the Vikings arrived in Ireland over 1,000 years ago. Port trade was the main reason for Cork's development into the major city of today with quays and docks sited along the broad waterway of the River Lee. Many of the city's major exports including chemicals, brewing and food processing are exported through this important port.

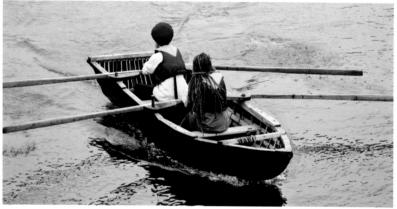

Sea to City Race

The annual Sea to City Race (An Rás Mór) begins in Crosshaven and finishes in the city via the mouth of Cork Harbour, Roches Point, Cobh Monkstown, Passage West, and Lough Mahon. This particular year there was a boat that caught my eye, if only for the contrast of dreadlocked figures rowing an old-fashioned currach.

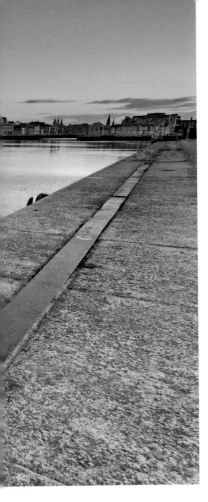

Blackrock Castle

A 50mm prime lens is a must for any photographer as, although cheap to produce, they are sharp as a razor and my own sample is a truly prized lens, which produced this wonderful gothic image of Blackrock castle.

Blackrock Castle is an eye-catching structure standing some 3 miles east of Cork City centre on the south bank of the River Lee. The original structure was built by Lord Deputy Mountjoy to defend the water approach of the city from pirates and other adventurers in the sixteenth century. The current castle was rebuilt by the Harbour Commissioners in 1829 and consists of a number of circular towers surrounded by the walls of earlier structures on the site. Blackrock Castle is currently home to an observatory and an award-winning science museum.

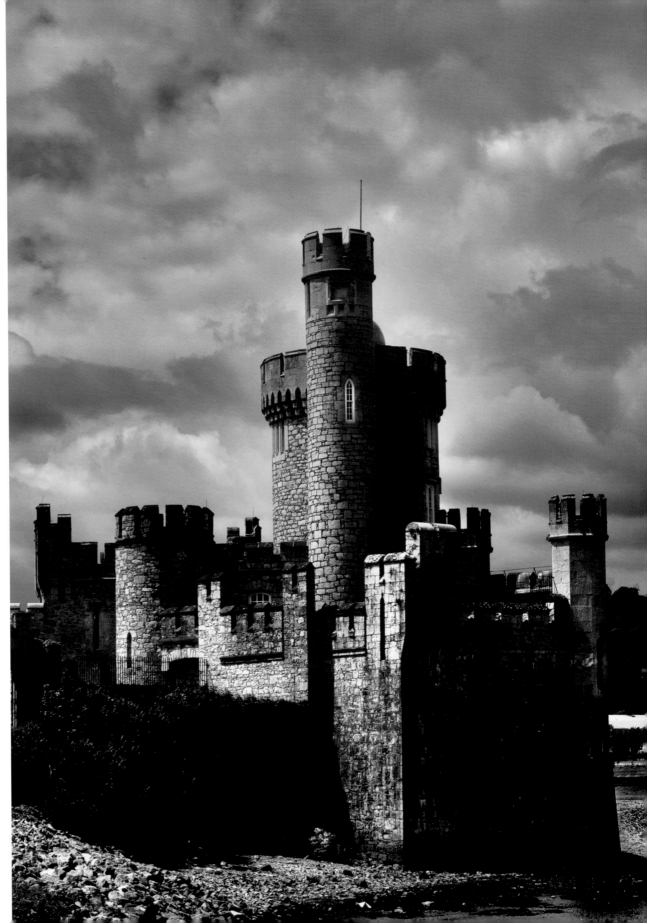

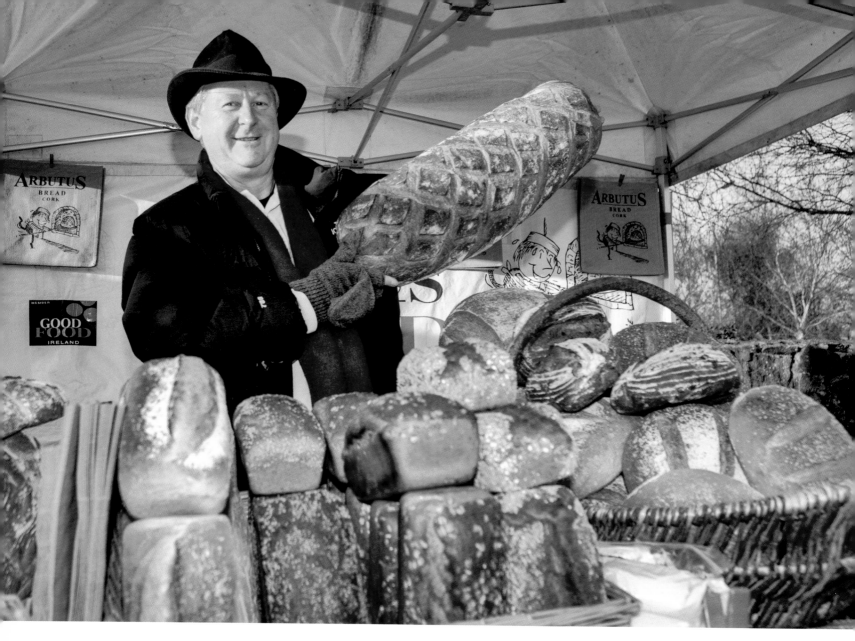

Arbutus Bread

Declan Ryan is simply a bread-making legend, and is truly one of Ireland's best artisanal bread makers. The Arbutus business has grown out of his garage to a staff of five full-time bakers in premises in Amnew industrial estate in Mayfield, Cork City. Declan uses mainly French techniques, having learned his craft first-hand from some of France's best bakers. The French influence has also led Declan to extend his bread range to croissant and pain au chocolat.

Like most artisanal food producers, Declan uses traditional techniques and uses no chemical additives or improvers. Declan can be found at farmers' markets throughout Cork: Macroom Market, every Tuesday, Mahon Market, Cork every Thursday, Midleton Market every Saturday as well as in many good food outlets nationwide.

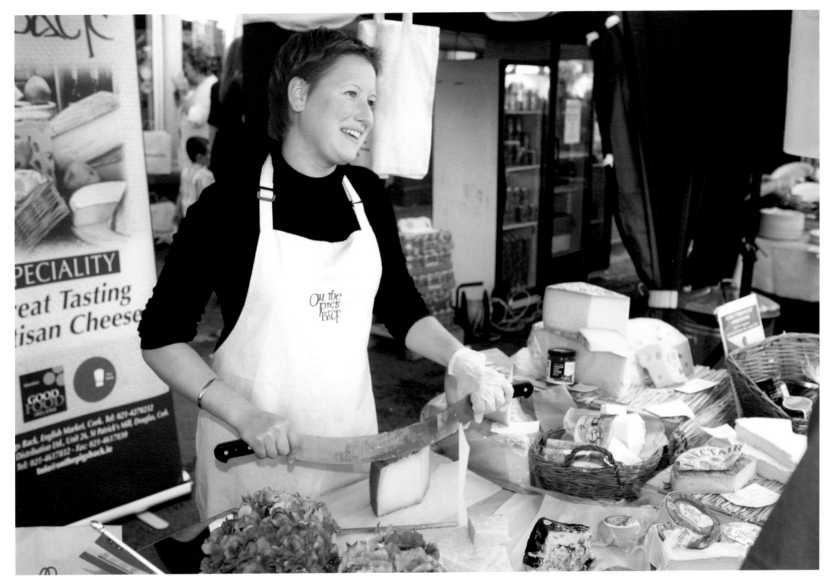

On the Pig's Back

On the Pig's Back is the creation of Isabelle Sheridan and is a treasure trove of all that is good about Irish and French food and what's even better is, On the Pig's Back has an outlet in the English Market in Cork City centre as well as at the Woollen Mills in the heart of Douglas.

They stock a wide range of Irish and French cheeses, an extensive French epicerie range including foie gras, cassoulets, sauces, dried mushrooms, mustards, galettes from Brittany, ready meals from a duck farm in Normandy and the best of Irish local products ranging from tasty fresh sausages, locally smoked bacon to homemade jams, sauces, dressings, chocolates and biscuits.

As Isabelle says, 'Our products are for those who see food and cooking as life's necessities as well as life's greatest pleasures.'

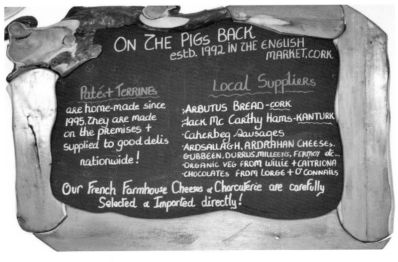

ON THE PIGS BACK
estb. 1992 IN THE ENGLISH MARKET. CORK

Patés + Terrines
are home-made since 1995. They are made on the premises + supplied to good delis nationwide!

Local Suppliers
· ARBUTUS BREAD - CORK
· Jack McCarthy Hams - KANTURK
· Caherbeg Sausages
· ARDSALLAGH, ARDRAHAN CHEESES.
GUBBEEN. DURRUS, MILLEENS, FERMOY etc...
· ORGANIC VEG FROM WILLIE + CAITRIONA
· CHOCOLATES FROM LORGE + O'CONNAILS

Our French Farmhouse Cheeses + Charcuterie are carefully Selected + Imported directly!

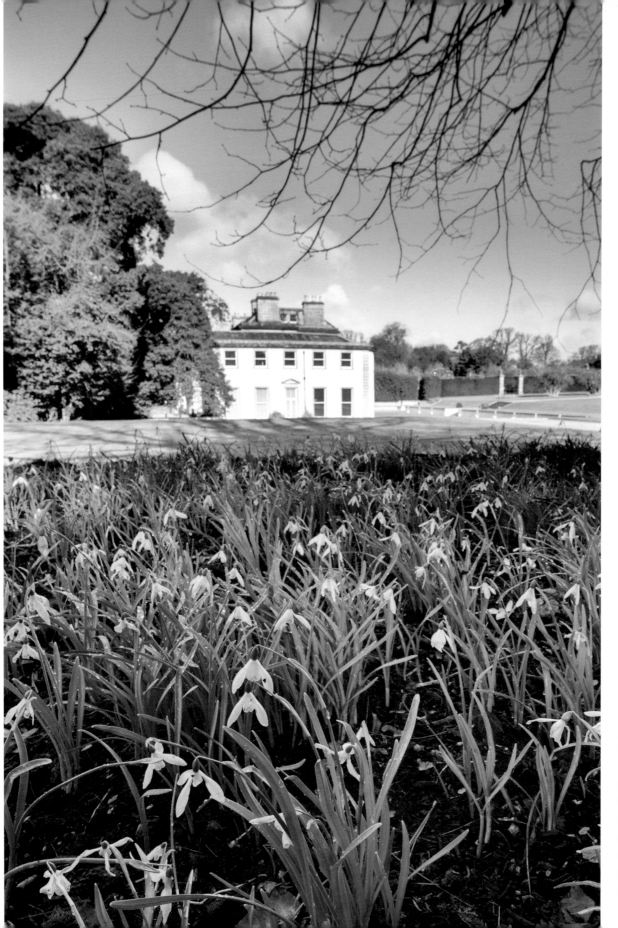

Fota House

We start our East Cork journey from Fota House. 'Fota' is derived from 'Fód te', meaning 'warm soil'. Fota, the former home of the Earls of Barrymore since 1627, now hosts Ireland's only wildlife park. The woods are also spectacular, full of bluebells and snowdrops.

EAST CORK

East Cork sweeps across the rich, fertile plains around Midleton and Youghal towards the border with County Waterford. In contrast to the wild landscape of West Cork, the tended landscape of East Cork is vibrant and full of some of the best produce from land and sea in Ireland. The interior of East Cork is rich in old castles that dominate the landscape. East Cork's rocky shoreline is lined with old watchtowers and its headlands are home to numerous lighthouses.

Food has always played a central role in East Cork's prosperity. Midleton is world-renowned for the quality of its whiskeys. The fishing fleet at Ballycotton unload their daily catch on the village's quayside. Youghal was the first place in Europe where potatoes and tobacco were grown after Sir Walter Raleigh brought them back from his expeditions to South America.

The Midleton Farmers' Market every Saturday is a particular highlight for any foodie, with the world renowned Ballymaloe Cookery School having a stall amongst other stars of Irish food.

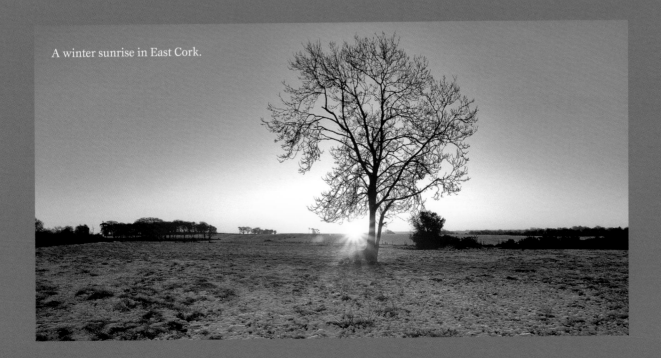

A winter sunrise in East Cork.

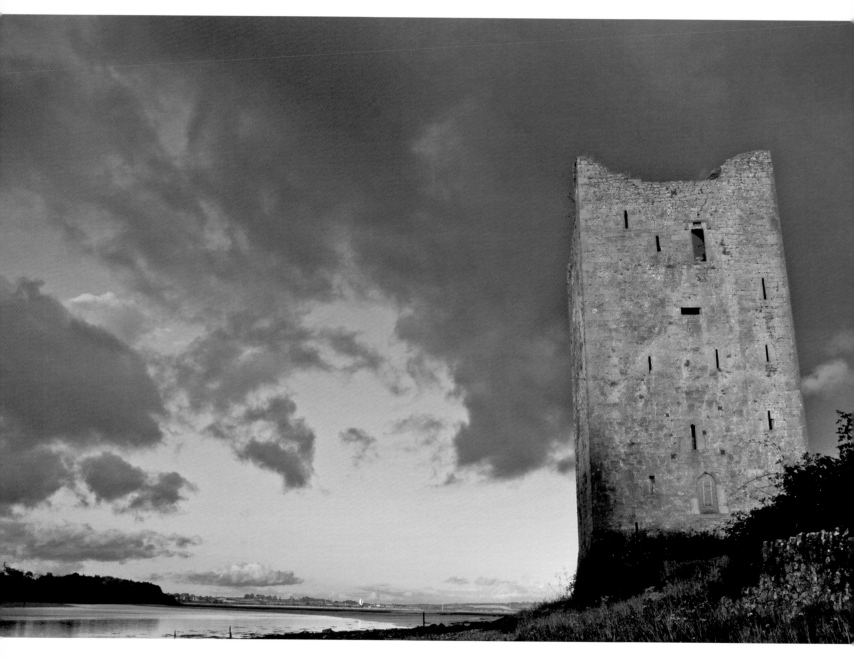

Belvelly Castle

Located on Great Island, Belvelly Castle is a fifteenth-century tower house and has been a real photographic muse. It's such a curiosity, with a fully intact tower house guarding the waterway and the only bridge leaving the mainland for Great Island. It is a place that almost takes you back to its heyday; your imagination can run wild,

picturing how it once might once have been. After photographing the tower many times during the day, the results were disappointing: a grey tower and blue skies image, a fairly typical shot nothing to write home about. However, researching the location of the tower with regard to the setting and rising sun proved that the sun would set casting its

glow on the tower on its 'best side' (yes, buildings can have a more photogenic side as well!). The sun did as predicted, casting its golden light on the tower during that fabled hour known amongst photographers as the 'golden hour' just before sunset, resulting in this glowing Belvelly tower in the image.

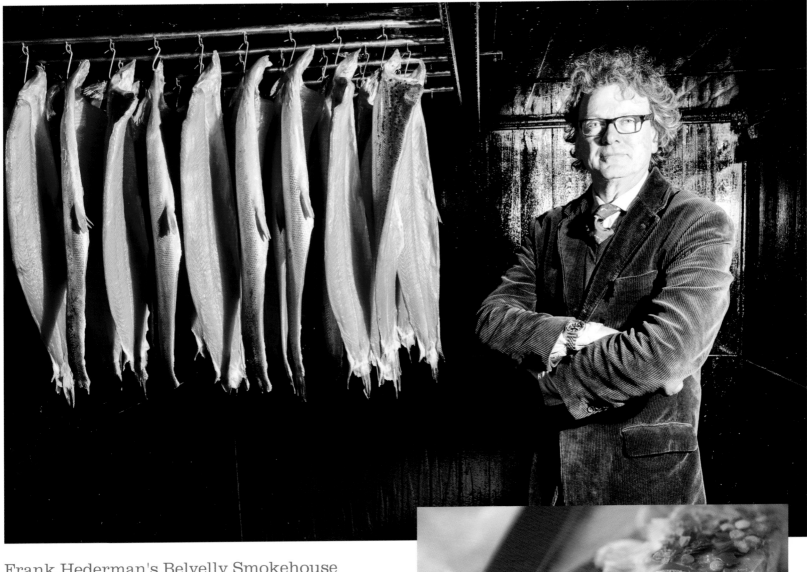

Frank Hederman's Belvelly Smokehouse

Just around the corner from Belvelly Castle is Frank Hederman's Smokehouse. This is no ordinary smokehouse, it is 'the' oldest traditional smokehouse in the country and Frank himself is artisanal food-producing royalty. In fact, his smoked fish has been served to royalty, at the Queen of England's birthday.

Frank does most of his business in London and many famous names, such as Heston Blumenthal, Richard Corrigan and Rick Stein, have championed his top-quality produce.

Frank has a black traditional smoker, with some beautiful lengths of salmon hanging by tenterhooks – 'that's tenterhooks with a "t" not tenderhooks and is where the expression comes from,' Frank explains.

Frank says his system of smoking his fish is the simplest in the world, however dig a little deeper and you will find that Frank uses beech wood chips, which are specially made for him in the UK and is an indication of the attention to detail that over twenty-five years in the business has afforded him.

Frank's products include smoked, organic salmon, smoked silver eels, smoked mackerel, smoked mussels and smoked garlic.

After a good morning catching the sunrise in Ballycotton there is nothing like Frank Hederman's smoked salmon straight from the market, with Arbutus bread and Ardsallagh goats' cheese, to fill an empty stomach … delicious!

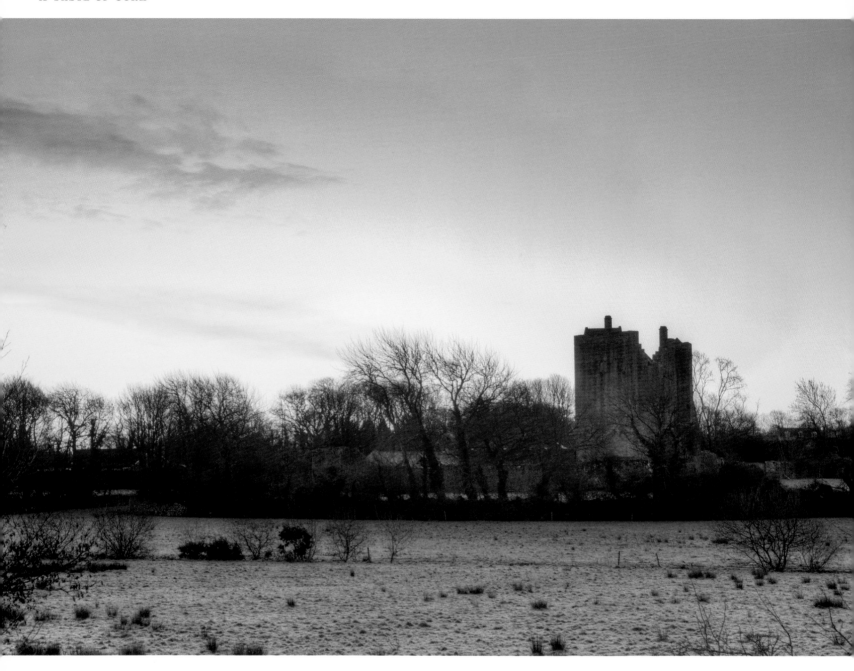

Barryscourt Castle

Close to Carrigtohill, Barryscourt Castle
is the sixteenth-century seat of the
Barry family. The castle fell into disuse
in the seventeenth century, but it has
been fully restored by the Irish state in
recent years. Today it is a magnificent
example of an Irish tower house, with
its intact outer defence wall complete
with corner towers.

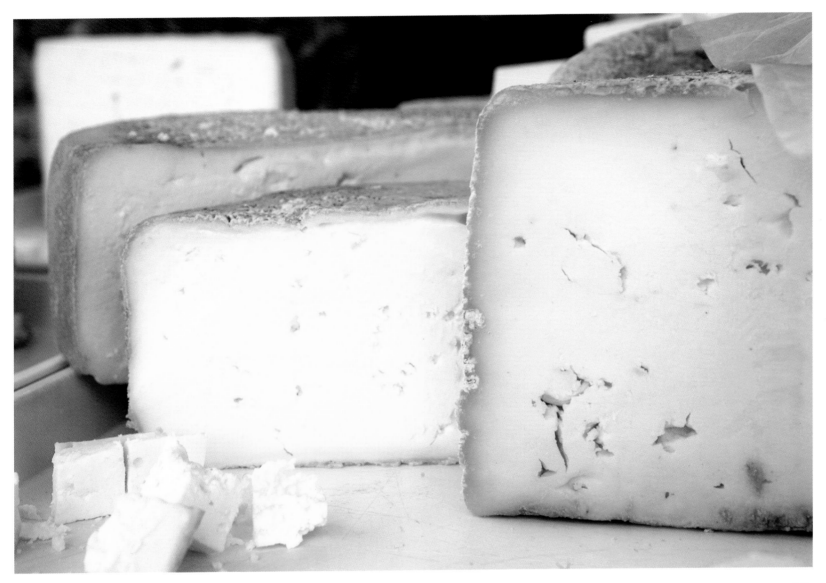

Ardsallagh

Ardsallagh cheese is a handmade goats cheese made on a family farm near Carrigtohill in East Cork. The cheese has been made by the Murphy family for over ten years from a herd of several hundred goats that provide the milk to make the cheeses, yoghurt and bottled milk. Ardsallagh goats cheese is a multi-award winning cheese and it can be found in local farmers' markets and supermarkets throughout Ireland.

The soft cheese is handmade in the dairy using a slow traditional method.

Ardsallagh hard goats cheese is a semi-hard mild cheese that develops its flavour as it matures. The family also make a smoked hard cheese through a process of smoking the cheese over beech-wood to give it a complex smoky flavour. With a permanent stand at the Midleton Farmers' Market, every Saturday from 9 a.m. to 2.30 p.m., the Murphys offer free tasters and plenty of chat about their wonderful cheese products.

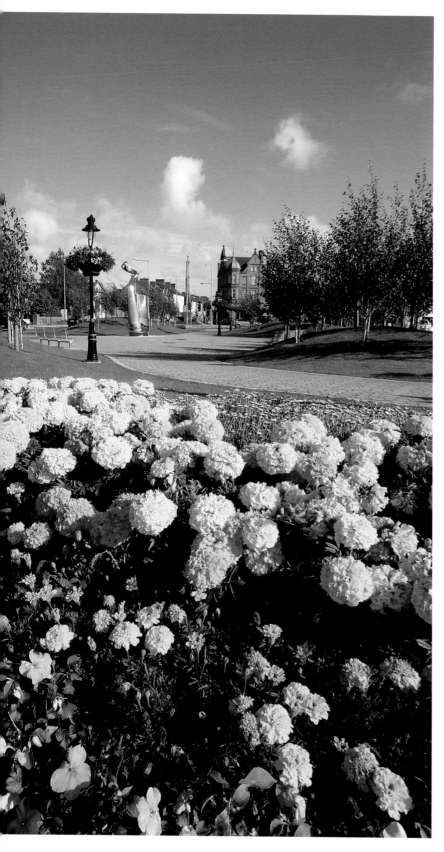

Midleton

Midleton is certainly the gourmet capital of East Cork, with a thriving Farmers' Market and some of the finest restaurants such as Finin's (Midleton's most established) and SAGE the new kid on the block.

Finin of Finin's restaurant stands in front of some of the fabulous paintings on display in the restaurant.

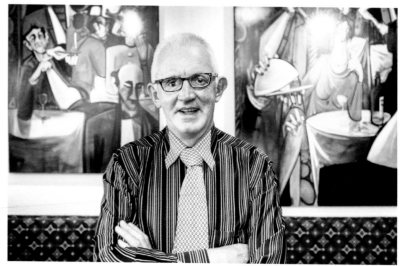

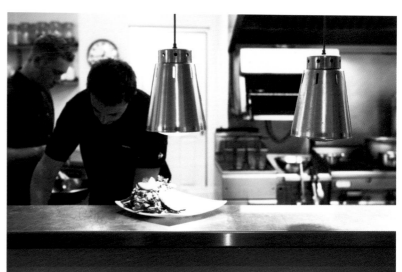

Kevin Aherne of SAGE restaurant plating up. Other restaurants of note are The Farmgate, Raymond's and O'Donovan's. Arguably Midleton has more in common with the market towns in the south of France than with other market towns in Ireland. Having its own farmers' market, a fresh fish shop 'Ballycotton Seafood' and several top restaurants emphasises an obsession with good food. But it is Midletons hosting of an annual food festival that marks it out as the foodie citadel of the east.

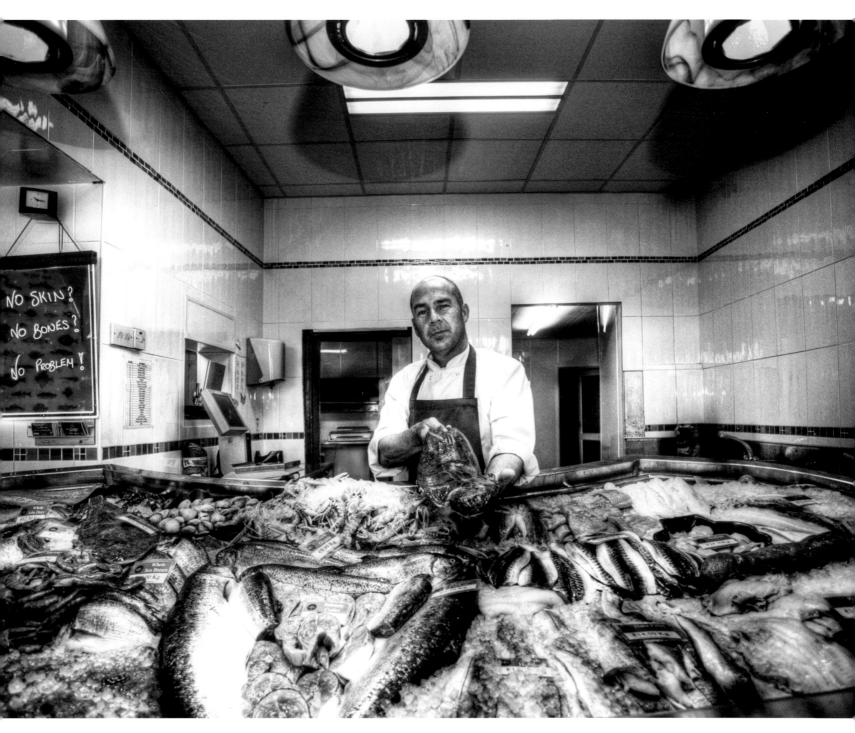

Ballycotton seafood, Midleton, County Cork.

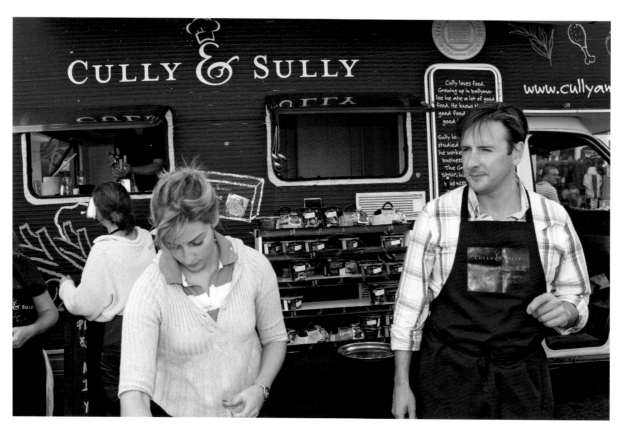

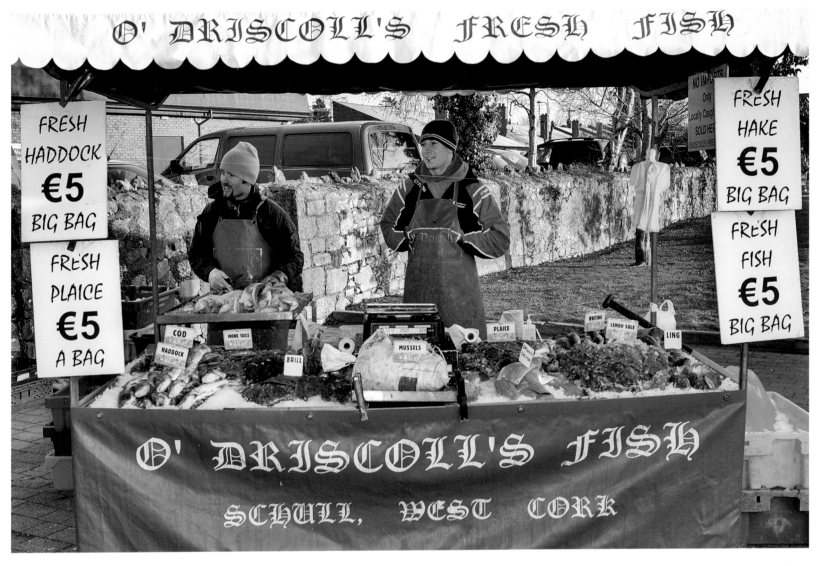

O' DRISCOLL'S FRESH FISH

FRESH HADDOCK €5 BIG BAG

FRESH PLAICE €5 A BAG

FRESH HAKE €5 BIG BAG

FRESH FISH €5 BIG BAG

COD
HADDOCK
MONK TAILS
BRILL
MUSSELS
PLAICE
WHITING
LEMON SOLE
LING

O' DRISCOLL'S FISH

SCHULL, WEST CORK

Midleton Farmers' Market

Midleton Farmers' Market is bulging with produce which can be bought direct from the producers, such as Ardsallagh goats cheese, Ballymaloe House, Frank Hederman smoked fish, Arbutus bread, O'Connails chocolatiers, Green Saffron Indian Spices, Dan Ahern's organic meats, and O'Driscoll's fresh fish.

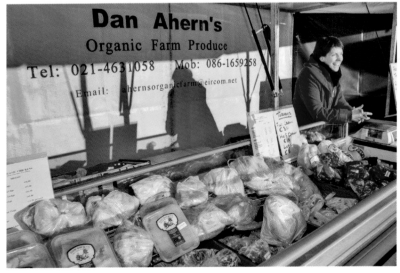

Dan Ahern's
Organic Farm Produce
Tel: 021-4631058 Mob: 086-1659258
Email: ahernsorganicfarm@eircom.net

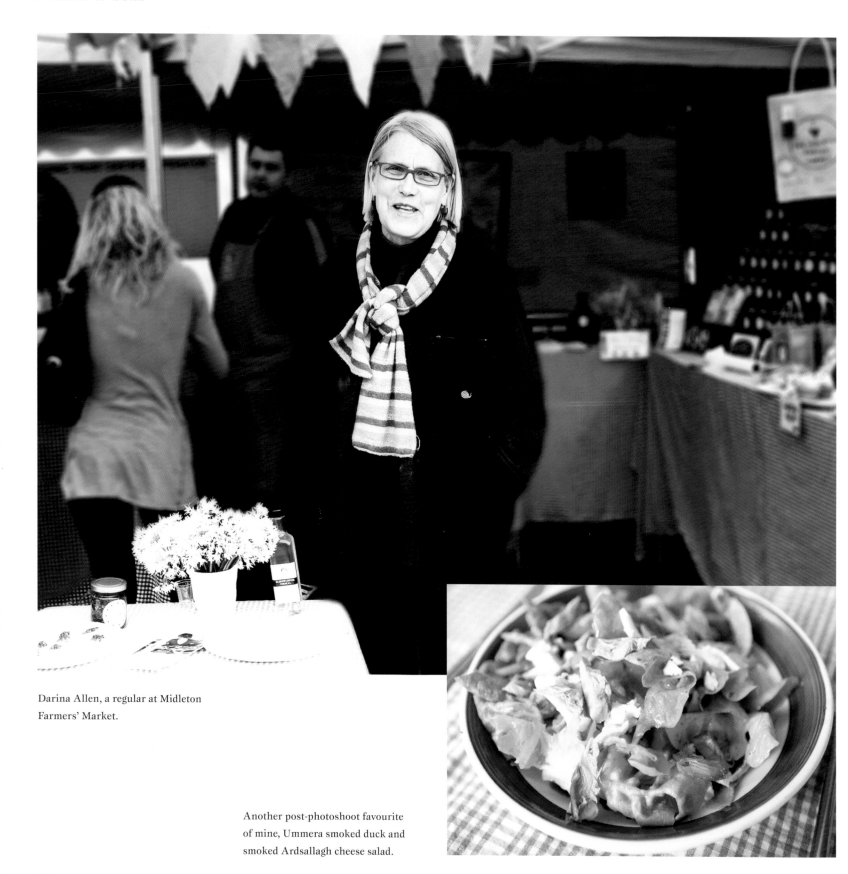

Darina Allen, a regular at Midleton
Farmers' Market.

Another post-photoshoot favourite
of mine, Ummera smoked duck and
smoked Ardsallagh cheese salad.

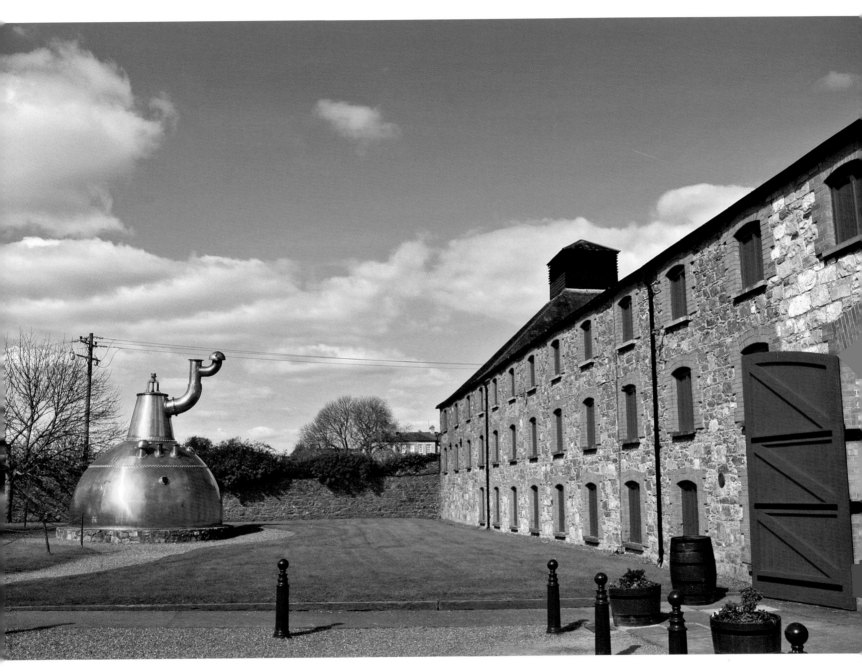

Midleton is probably more famous for whiskey than its food, but Jameson is *the* whiskey. The above image shows Midleton Distillery and its striking red doors .

Roche's Point

Roche's Point is the outermost point of land that marks the entrance to Cork Harbour. It is a spectacular icon on the landscape, poised at the mouth of the legendary Cork Harbour which is the world's second largest natural harbour after Sydney Harbour. The lighthouse at Roche's Point gives splendid views of the numerous yachts, trawlers and cargo boats that ply these waters.

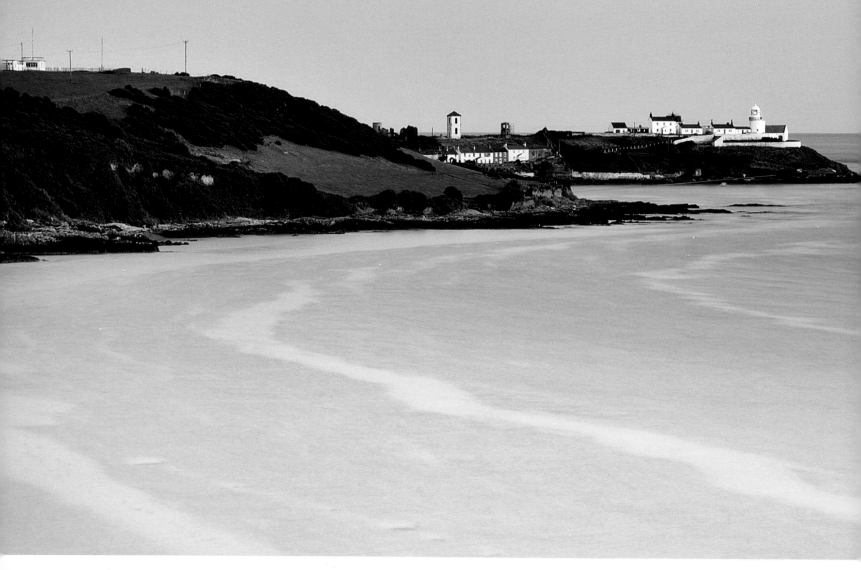

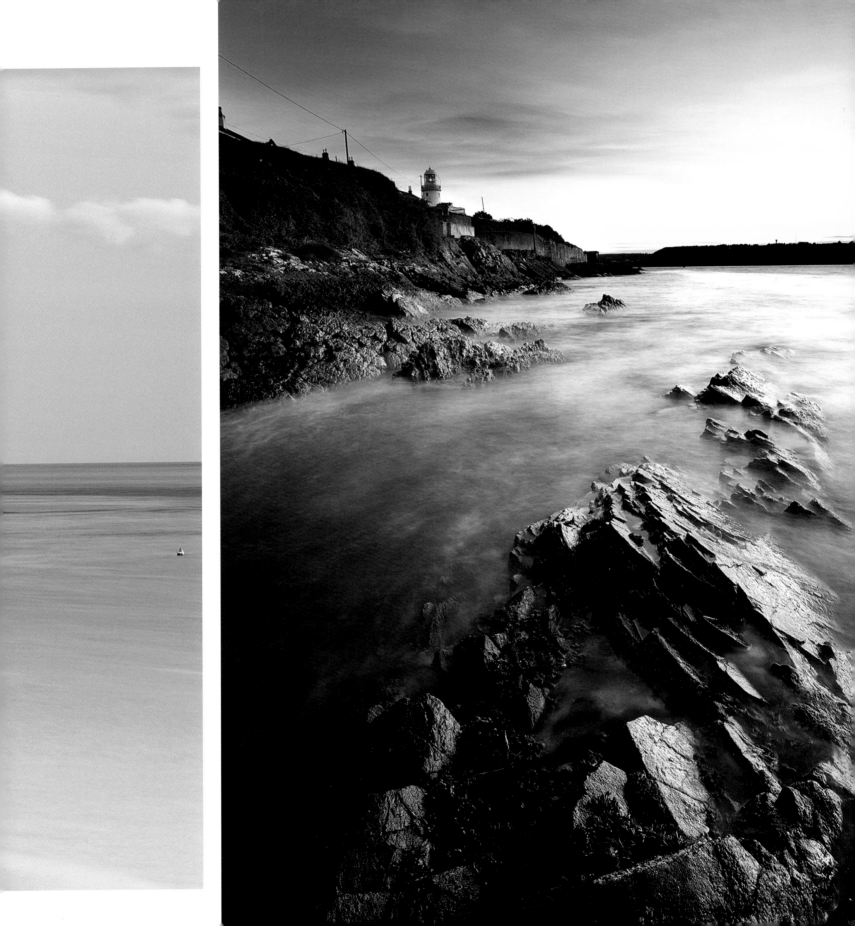

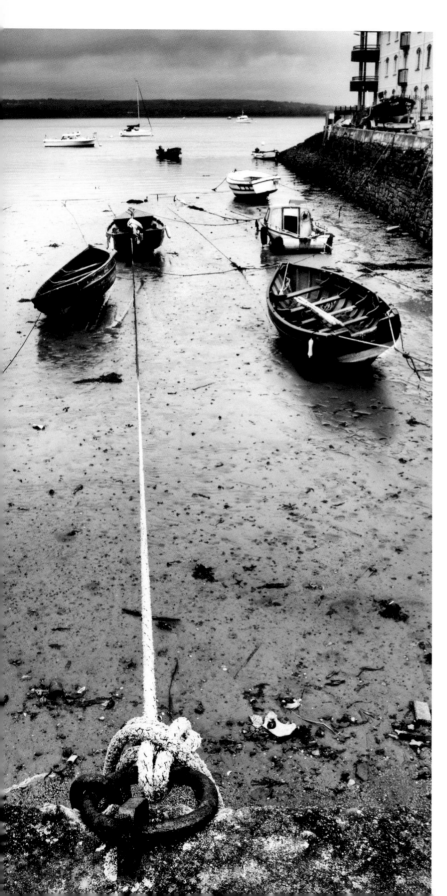

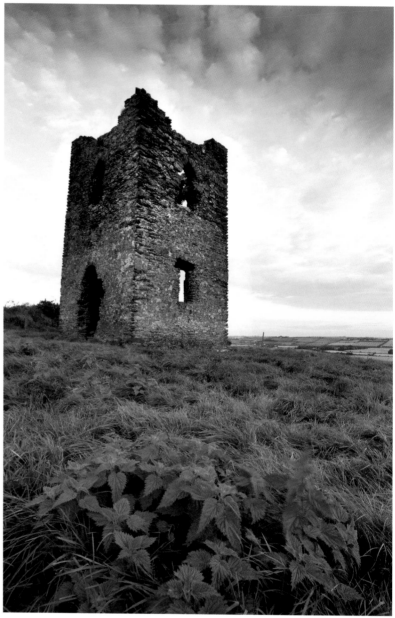

This watchtower overlooks Ballycotton Harbour and Cloyne with a view that is second to none.

'Tied up', Youghal.

Ballycotton

Ballycotton Harbour, a popular place to fish, at sunset on a warm summer evening.

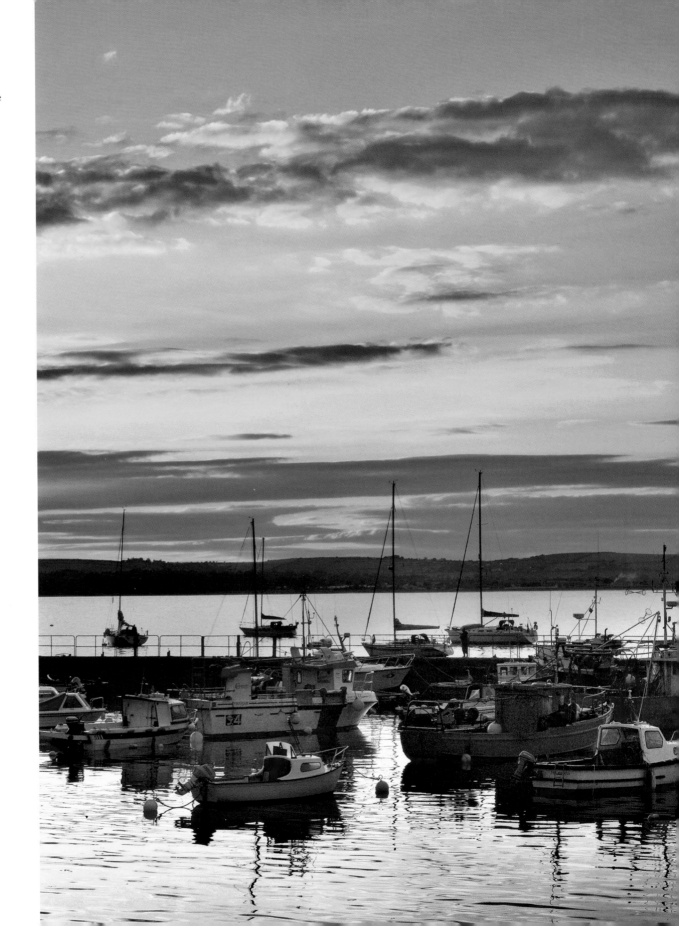

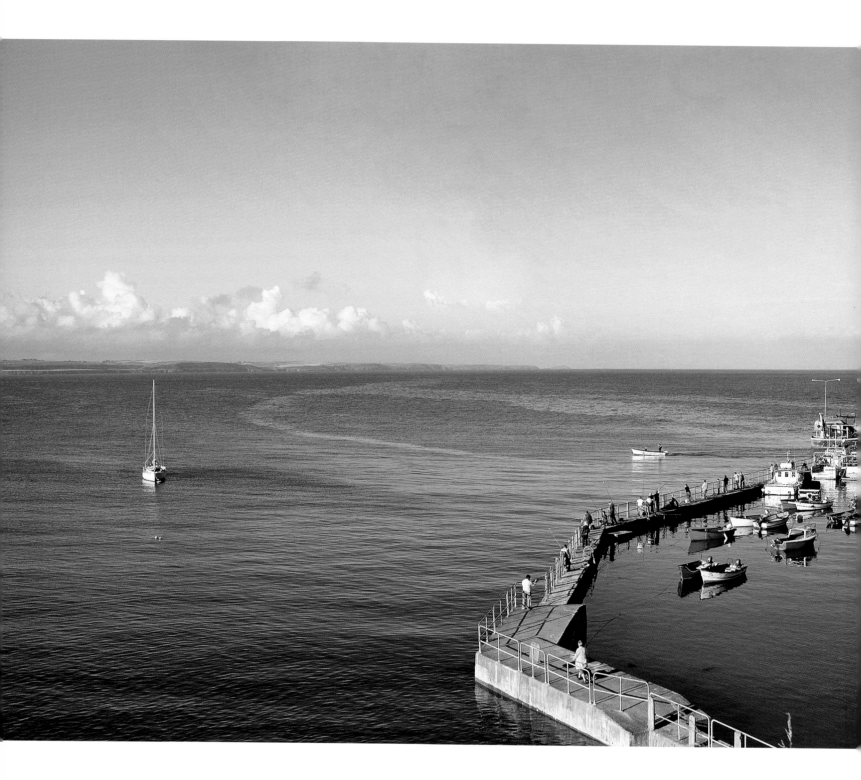

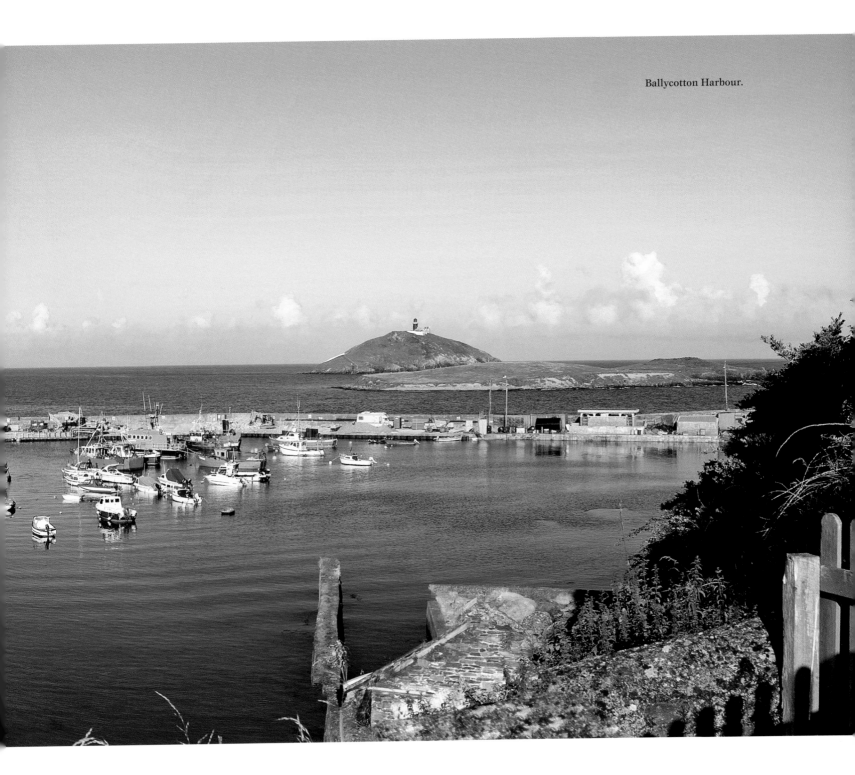

Ballycotton Harbour.

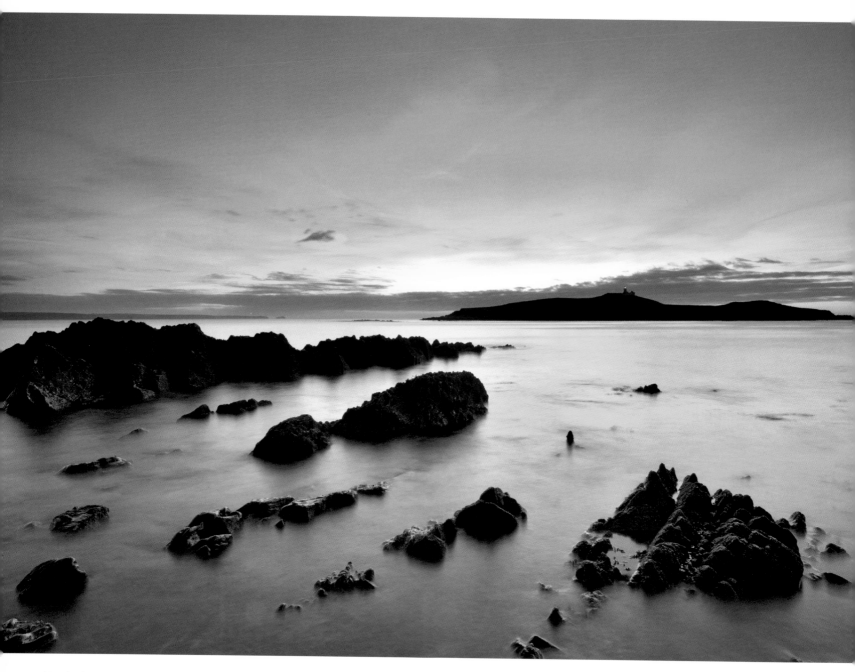

'Awakening', Ballycotton at dawn. Ballycotton is a favourite haunt of mine, mainly because this one location contains many of the things that are often the focus of any landscape photographer, namely the sea, lighthouses, boats, islands, interesting rocks and so on. Throw in the dawn sky and you get a shot like 'Awakening', in which the sun is illuminating the sky to the east behind the Ballycotton lighthouse which is shining its own red light in the half-light of the morning. The red light in this scene often brings to life, (although red), a passage in F. Scott Fitzgerald's classic *The Great Gatsby*, 'Involuntarily I glanced seaward - and distinguished nothing except a single green light, minute and far away'.

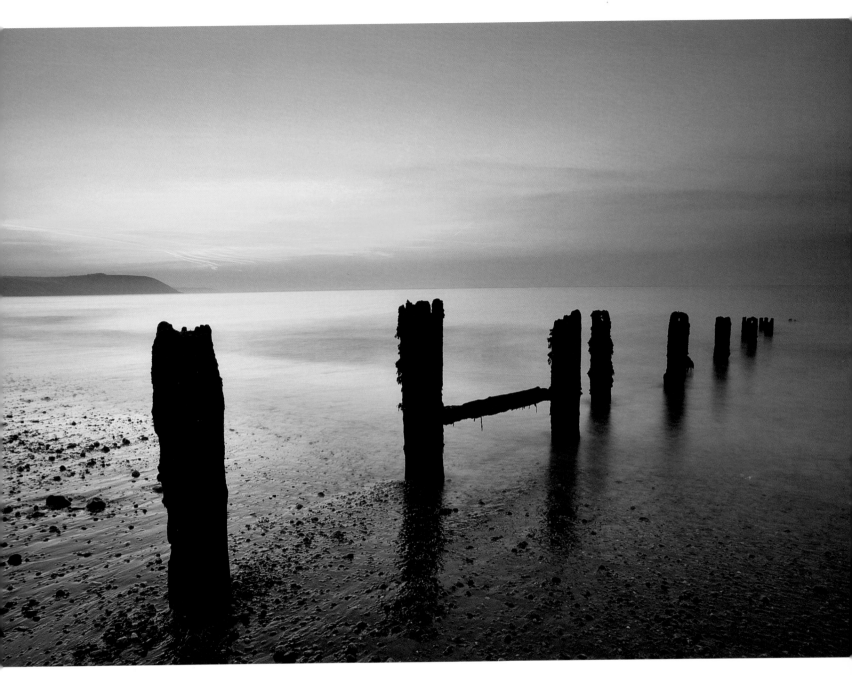

Youghal

The tide was perfect, the groynes were hard to see in the dark and the sun was threatening to rise on the horizon whilst readying this composition in the half light. Nonetheless, well wrapped up from the cold, and using a 20mm lens resulted in this enduring image. This shot is one of a pair of some iconic groynes taken as the sun rises on the magnificent 5-mile-long stretch of sandy beach at Youghal.

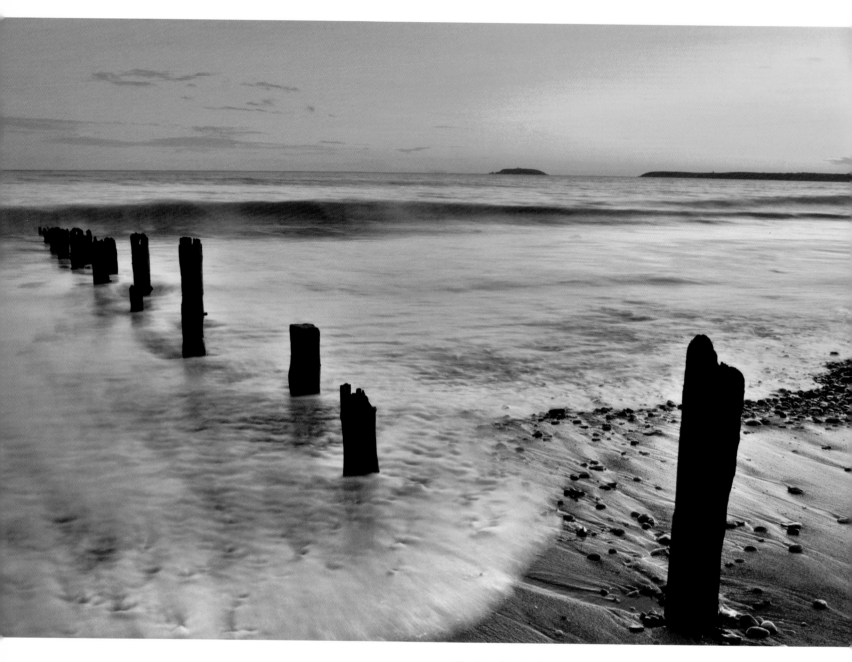

The shot above is the same stretch of beach at sunset, looking towards Capel Island. Youghal is a historically significant town as Sir Walter Raleigh was mayor here from 1588 to 1589. Tradition has it that he planted the first potatoes and smoked the first tobacco in Europe here after bringing them back from the New World. There is simply nothing to describe the feeling of watching the sunrise over this beautiful and historic beach, with the sound of the waves beating against the shore.

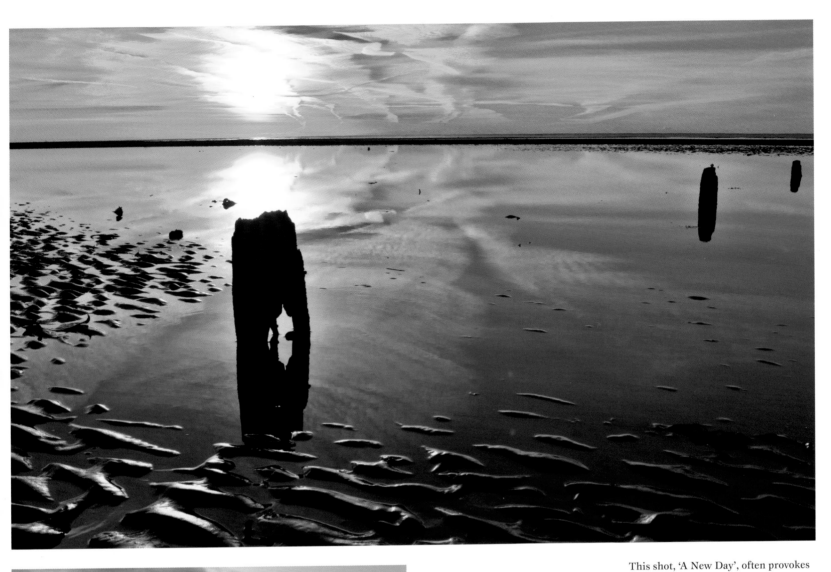

This shot, 'A New Day', often provokes an uplifting feeling in anyone who observes it, leaving the viewer feeling more positive about the rest of their day. Certainly on the morning after this shot was taken at Pilmore Strand in Cork there was a special energy and a special sense of the beauty of the earth.

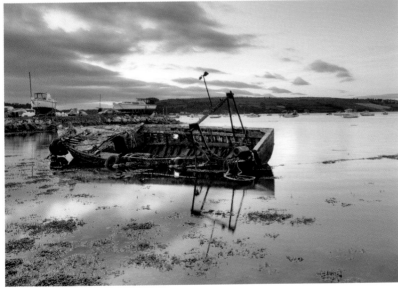

Old boat, East Cork.

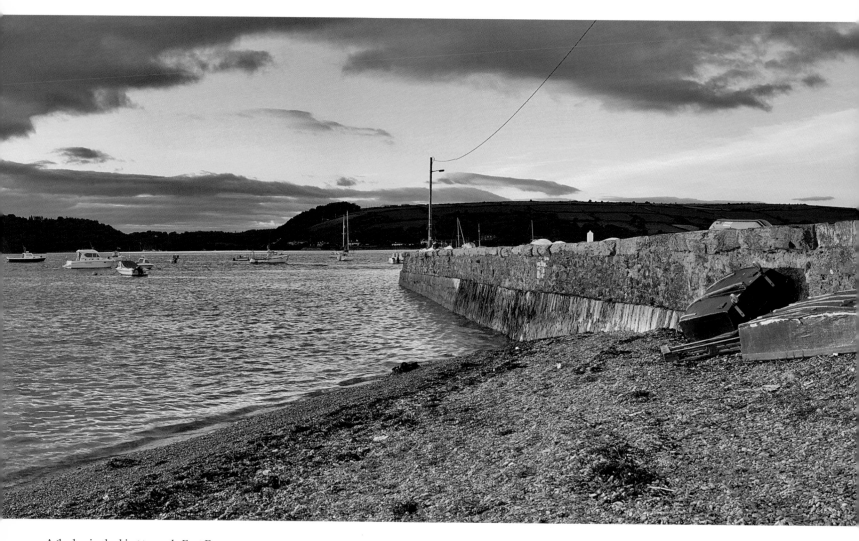

Aghada pier looking towards East Ferry and Marlogue at golden hour. It is a great place to watch the sun go down, particularly after a tasty meal at the Pepperstack Bistro at Rosie's Bar in Aghada, just across the road.

Cobh

Picturesque Cobh was, for many years, the port of Cork and has always had a strong connection with Atlantic crossings. The *Titanic* made its last stop here before its fateful voyage in 1912. When the *Lusitania* sank off the Old Head of Kinsale in 1915, it was here that many of the survivors were brought and the victims buried. In the British era it was known as Queenstown, because it was where Queen Victoria arrived in 1849 on her visit to Ireland. Nowadays, Cobh is full of brightly coloured buildings that contribute to

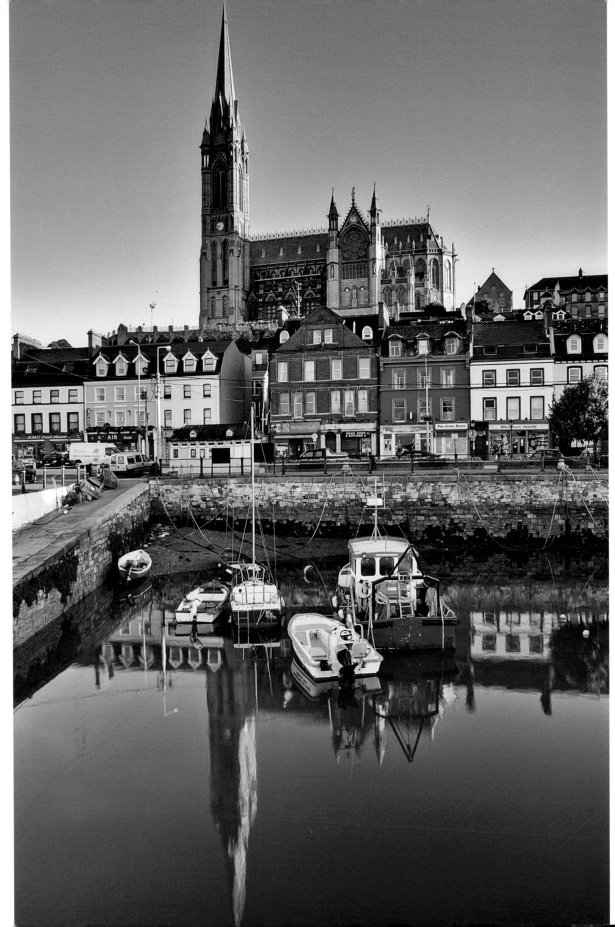

the aesthetic appeal. Cobh is dominated by the massive, but comparatively new cathedral, which stands on a huge platform overlooking the town. The cathedral is named after St Colman, who is the patron saint of the local diocese of Cloyne. Construction of the French Gothic-style cathedral began in 1868 and was finished in 1915. The Irish emigrant communities in Australia and the USA contributed much of the construction costs.

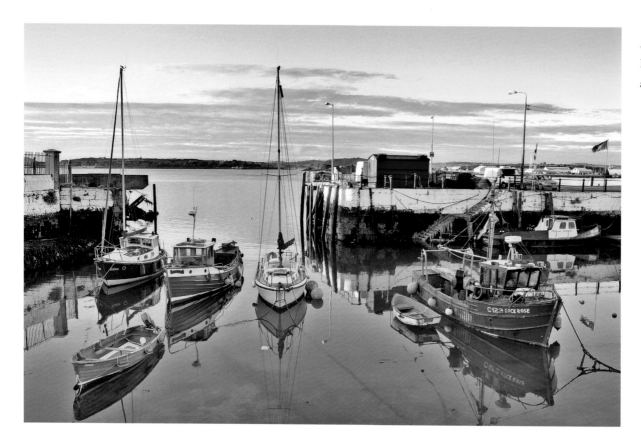

An early morning view of Cobh Harbour, looking onto Spike Island and Hawlbowline.

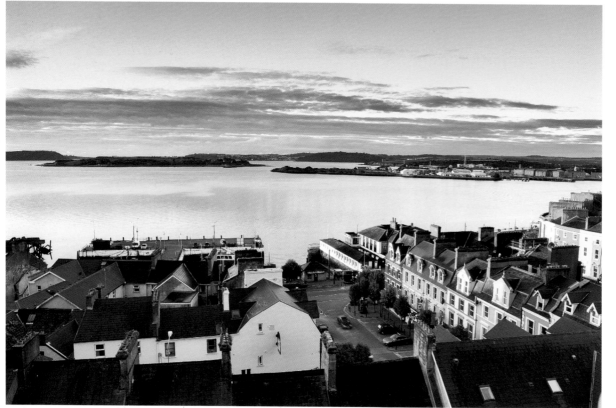

A statue in memorial of the sinking of the *Lusitania* in Cobh.

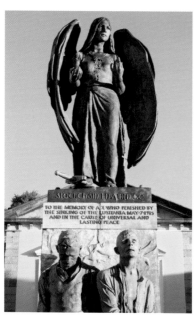

NORTH CORK

North Cork is a large region bordering the counties of Limerick and Tipperary. The north-western area is quite mountainous, but the hills become gentler as one moves eastwards towards the Blackwater Valley. People have lived here since the dawn of time, as evidenced by Ireland's largest megalithic wedge tomb at Labbacallee. North Cork is home to many dramatic and imposing castle ruins, such as at Kanturk, Mallow and Glanworth.

The Golden Vale, shared by Cork with Limerick and Tipperary, is reputed to be Ireland's finest agricultural land. The quality of the cattle and dairy produce from this region are legendary and form the cornerstone of Ireland's agricultural industry.

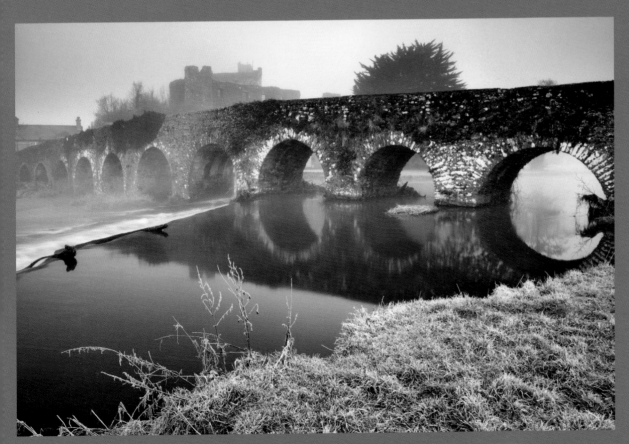

Glanworth

Situated to the south-west of the Kilworth Mountains, Glanworth is a small village with a wealth of history. The village skyline is dominated by the ruins of a fine thirteenth-century Norman castle built on a limestone bluff. The castle belonged to the Roche family, who ruled most of North Cork at the time. Underneath the castle ruins, the River Funshion is spanned by a fine old bridge of thirteen arches. The bridge was built in the mid-fifteenth century and is certainly the oldest public bridge in Ireland, although local people claim it to be the oldest public bridge in Europe.

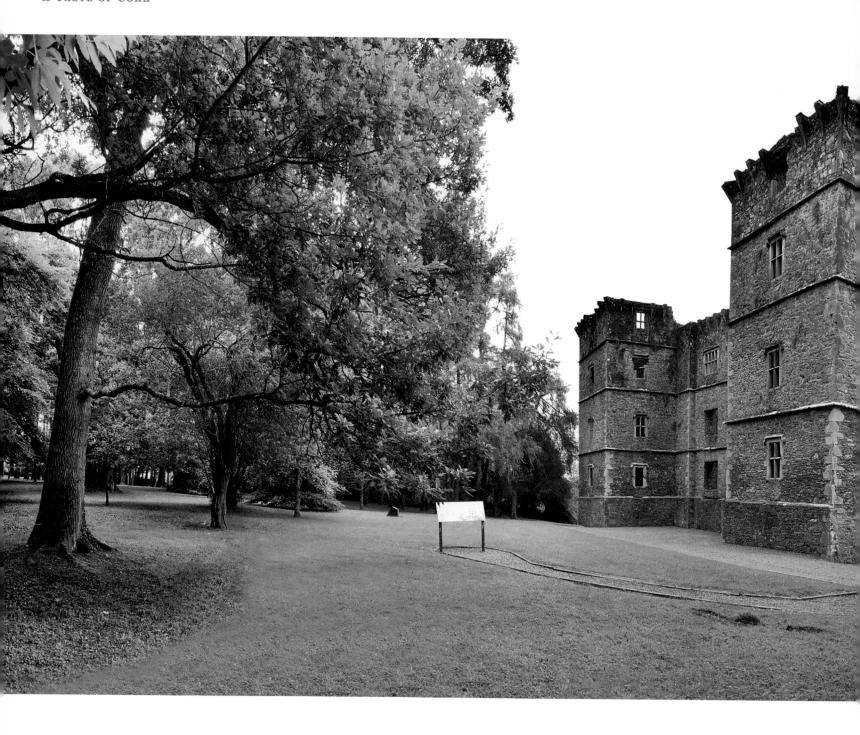

Kanturk Castle and Kanturk

Kanturk Castle was built as the chief residence of the Lords of Duhallow in the seventeenth century. It is said that the castle's mortar was mixed with the blood of the builders who were forced to work on its construction. The English authorities objected to an Irish chief building such a large mansion and didn't allow it to be roofed. Kanturk Castle is a mixture of tower-house and Italian Renaissance mansion, which reflects the dual nature of country house and castle of the era.

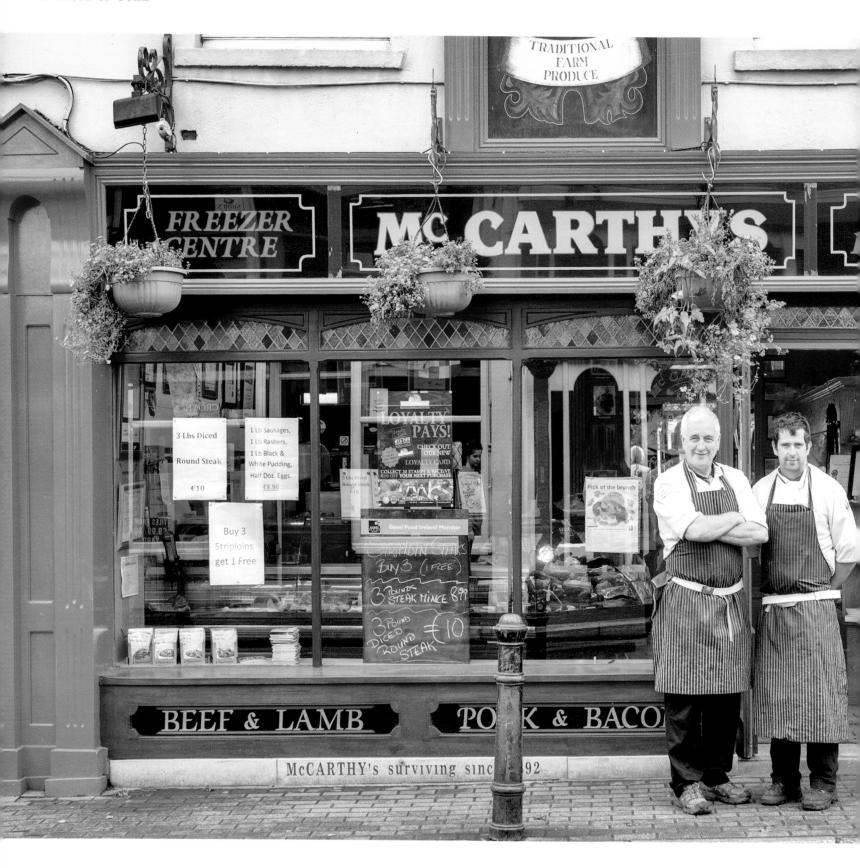

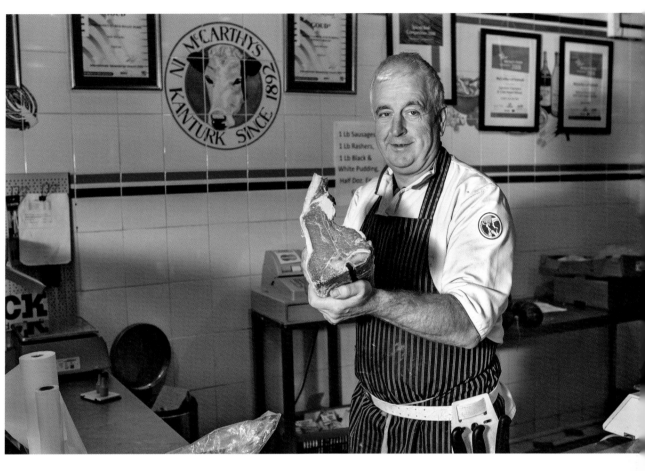

McCarthy's of Kanturk

While Kanturk Castle is an absolute must for any visit to North Cork, no visit to Kanturk (from the Irish *Ceann Toirc* meaning 'Boar's head') would be complete without a trip to McCarthy's traditional artisanal butcher's. As the stone at the front of their shop says, McCarthy's have been 'Surviving since 1892' and Jack and Tim are the fourth and fifth generation of McCarthy's to run the butcher's shop.

This is no ordinary butcher's shop, however, as in September 2010, twenty-five members of the Black Pudding Fraternity, or 'Confrerie des Chevaliers du Goute Boudin' paraded through Kanturk in full regalia before awarding Jack a gold medal for his 'Boar's Head' Kanturk black pudding. The fraternity was set up in 1963 in Mortagne-au-Perche, in France, by a group of lovers of fine food to promote the tradition of eating the black pudding.

While experts in the black pudding field, the McCarthy's are not just black pudding producers. These artisanal butchers employ traditional curing techniques and sell nitrate-free pork products produced locally from free-range pigs. With innovative products, like their award winning Sliabh Luachra air-dried beef and their fabulous spiced bacon, these are butchers who stand out from the crowd. McCarthy's also sell a full range of venison products farmed at Millstreet Country Park.

The McCarthy's have an online shop, so lovers of quality free-range meat products don't have to make the pilgrimage to Kanturk, but can browse and buy online.

Mallow Castle, Mallow.

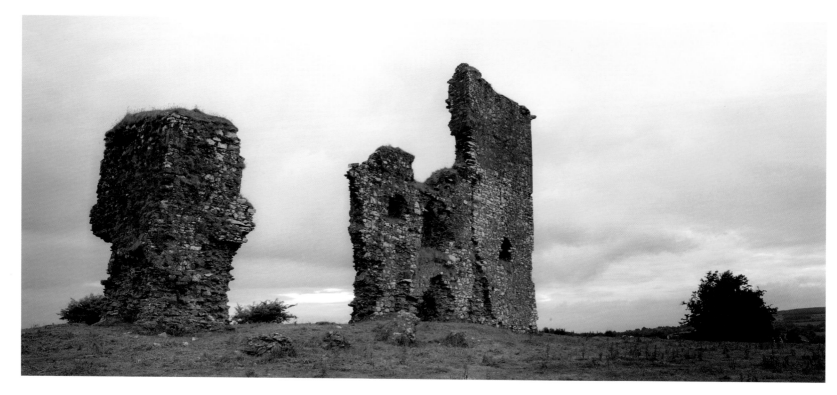

Castle Barrett

The ruins of Castle Barrett are a striking sight for travellers on the road from Cork to Mallow. It dominates a grassy plateau with panoramic views of the rich farmland of central and north County Cork. The castle was inhabited by the Barrett family until the Battle of the Boyne in 1690. The Barrett family had, however, backed the losing forces of King James and their lands were consequently forfeited and the castle destroyed.

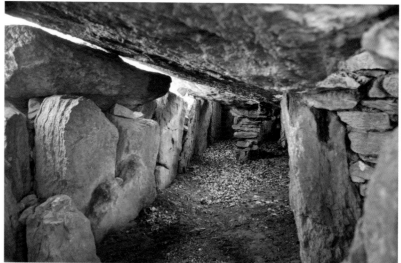

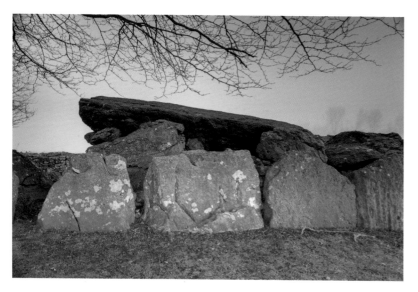

Labbacallee Megalithic Tomb

Labbacallee Megalithic tomb lies a couple of kilometres south of Glanworth. It was constructed over 4,000 years ago during the Bronze Age and it is the largest wedge tomb in Ireland. Three enormous capstones slope down to the back of the burial chamber where a number of human remains were discovered during a 1930s archaeological excavation. During the spring and autumn equinoxes, the setting sun shines directly down the chamber and illuminates it with a beam of sunlight.

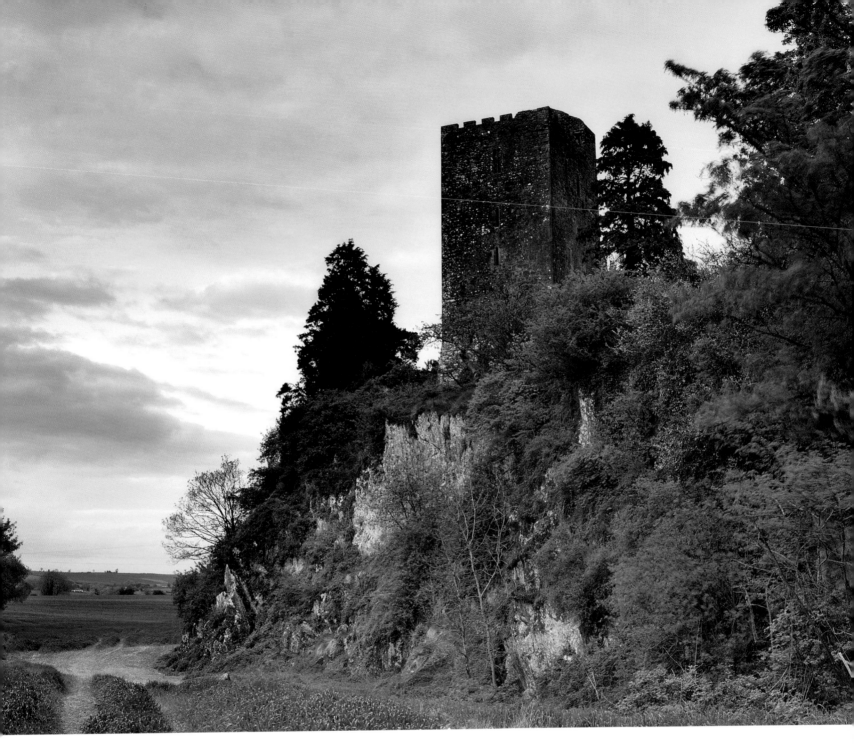

Conna Castle

Conna is a village in East Cork, close to the county boundary with Waterford on the River Bride. Conna is best known for its castle, which is situated on a limestone crag overlooking the river. The original castle was built in the middle of the fourteenth century and it was destroyed by Crown forces during the Earl of Desmond's rebellion in 1599. In more recent times, Conna made international headlines for being the home of Monty's Pass, who won the 2003 Aintree Grand National, the world's most famous steeplechase.

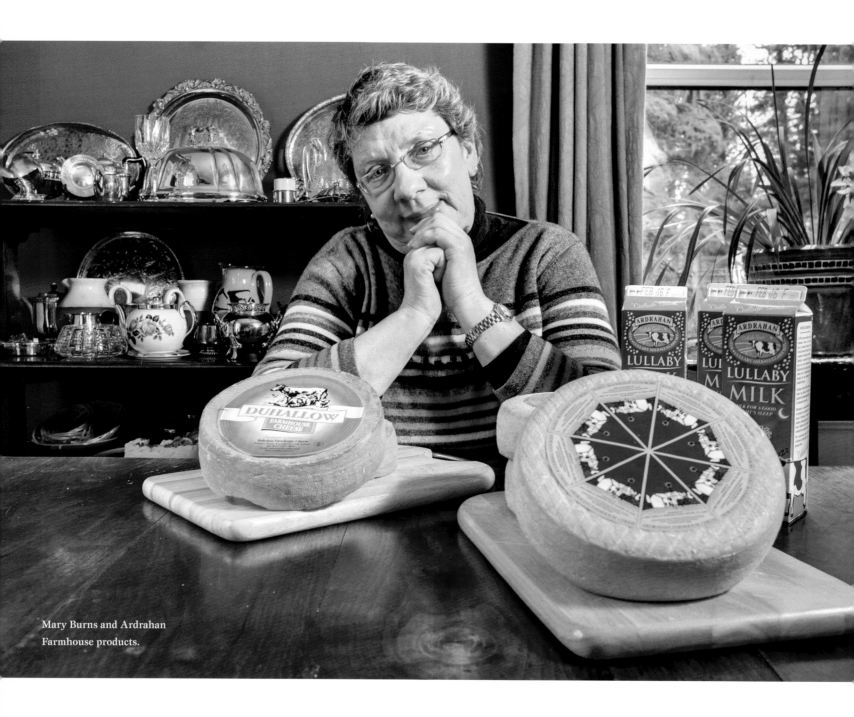

Mary Burns and Ardrahan
Farmhouse products.

Ardrahan Farmhouse Cheese

Ardrahan farmhouse cheese was founded in 1983 by Eugene and Mary Burns at their family farm in Kanturk, County Cork. Today the business is run by Mary and her son Gerald.

Ardrahan cheese is a handmade semi-soft cheese made by traditional methods. It has a nutty flavour, a pungent aroma and a buttery-textured, honey-coloured centre. It is made from pasteurised cow's milk from the cows on the Ardrahan farm, vegetarian rennet and natural starter culture.

Following the success of Ardrahan farmhouse cheese, Mary has now launched two further products, Duhallow farmhouse cheese, named after the locality, and Lullaby milk. Mary was particularly enthusiastic about the sleep-assisting properties of the Lullaby milk. To produce this magic milk, the Ardrahan cows are milked in the morning before daylight. Because the milk is created in the dark, as the animal sleeps, the milk has naturally higher levels of melatonin. Melatonin is a natural substance found in all our bodies. It is the melatonin Mary claims that makes the Ardrahan milk Lullaby milk.

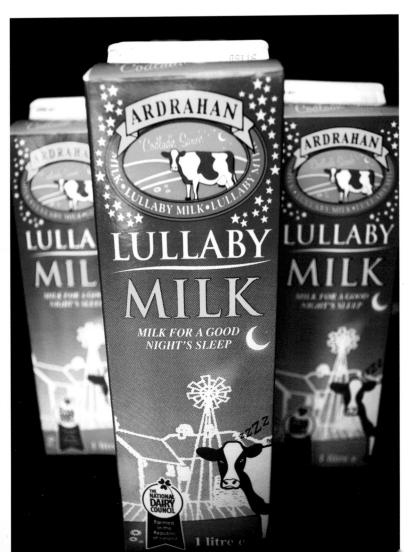

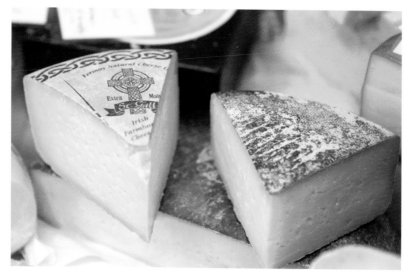

Fermoy Natural Cheese Company

Fermoy Natural Cheese Company is run by Frank and Gudrun Shinnick, and they produce a range of five different award-winning cheeses produced on their farm near Fermoy.

Liscarrol

Liscarrol is an unusual Irish village as at its heart lies the third largest Norman castle in Ireland. The view shown in this photograph is of the castle's main entrance. The impressive rear walls of the castle, which are fully intact, can be viewed from the local playground which backs onto the castle.

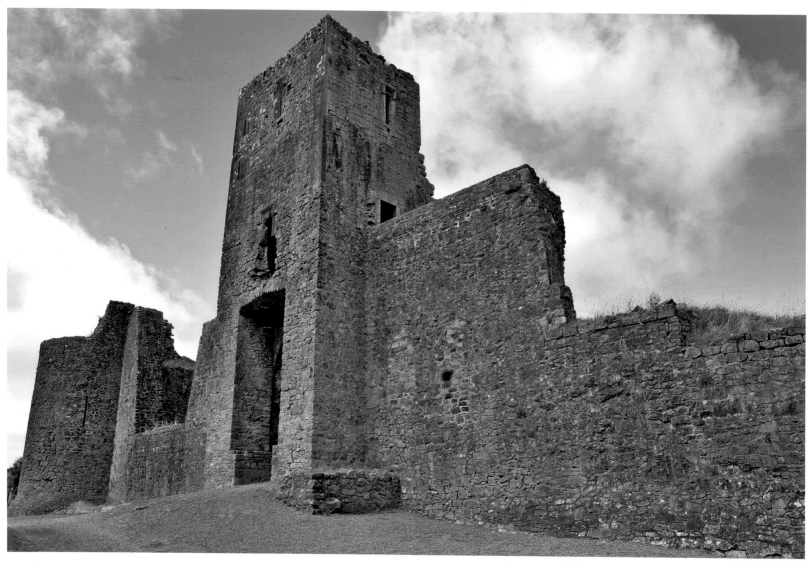

REFERENCES

Where to buy food mentioned in this book

The English Market: (Grand Parade Cork City. www.corkenglishmarket.ie)

On the Pig's Back: (The English Market Cork City, Douglas Woollen Mills, Douglas, Cork City. www.onthepigsback.ie)

Nash 19: (Princes Street Cork. www.nash19.com)

Manning's Emporium: (Ballylickey, Bantry www.manningsemporium.ie)

Hassets Bakery: (Main Street, Carrigaline)

Urru: (Bandon. www.urru.ie)

Mahon Points Farmers' Market: (Mahon Point Cork. www.mahonpointfarmersmarket.com)

Midleton Farmers' Market: (Midleton. www.midletonfarmersmarket.com)

Killavullen Farmers' Market: (Killavullen. www.killavullenfarmersmarket.com)

West Cork Markets: (www.westcorkmarkets.com)

Websites of producers mentioned in this book

www.arbutusbread.com

www.ardrahancheese.ie

www.ardsallaghgoats.com

www.carrigalinecheese.com

www.durruscheese.com

www.frankhederman.com

www.gubbeen.com

www.jackmccarthy.ie

www.milleenscheese.com

www.ummera.com

www.woodcocksmokery.com

Where to buy fine art prints of the images in the book

www.photogalleryireland.ie

ABOUT THE AUTHORS

Seán Monaghan

Seán Monaghan is a photographer based in Cork. Originally from Fermanagh, this book is very much a product of his exploration of Cork and his love of the fine food he has discovered in Cork.

Seán's work has been exhibited in Belfast and Cork and his landscape photography can be viewed and purchased at www.photogalleryireland.ie. Seán & Aidan Monaghan's wedding, portrait and music photography can be viewed at www.monophotography.ie.

Seán and Aidan are available for photographic commissions nationally and internationally.

Andrew Gleasure

Andrew Gleasure is originally from County Kerry, but has lived in County Cork for ten years. Andrew is the son of a farmer, meaning that he grew up with a deep love of nature. Coming from the countryside gives Andrew an appreciation of locally sourced, natural foods and their importance to the local economy. Andrew's many interests include local history and writing this book has he says, (tongue in cheek), been a pleasantly surprising revelation of County Cork's contribution to world affairs.